IMAGES
of America

HEART MOUNTAIN
INCARCERATION SITE

T0413497

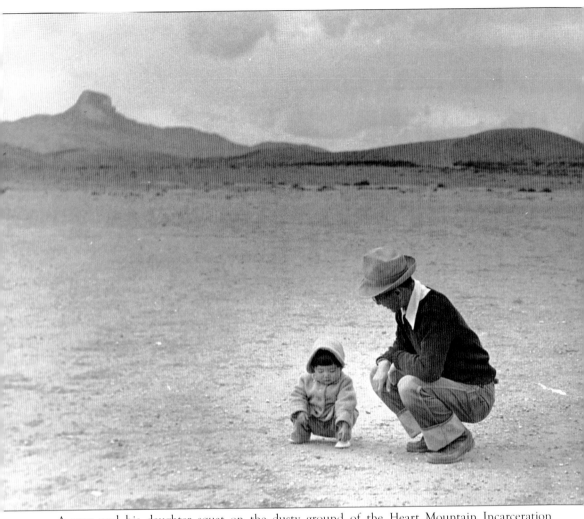

A man and his daughter squat on the dusty ground of the Heart Mountain Incarceration Site with the iconic mountain looming in the background. Between August 12, 1942, and November 10, 1945, more than 14,000 Japanese Americans lived behind the barbed wire here. (Okumoto collection.)

ON THE COVER: Two boys walk along "F" Street in the Heart Mountain Incarceration Site with the iconic mountain looming in the distance to the west shortly after the camp opened in August 1942. All of the camp's streets were unpaved and often choked with dust. (National Archives and Records Administration.)

IMAGES
of America

HEART MOUNTAIN
INCARCERATION SITE

Ray Locker and
the Heart Mountain Wyoming Foundation

ARCADIA
PUBLISHING

Published by Arcadia Publishing
Charleston, South Carolina

Printed in the United States of America

Library of Congress Control Number: 2024942983

For all general information, please contact Arcadia Publishing:
Telephone 843-853-2070
Fax 843-853-0044
E-mail sales@arcadiapublishing.com

Visit us on the Internet at www.arcadiapublishing.com

*To the 14,000 Japanese Americans who were forced to call
Heart Mountain home during World War II. They and
their families have set an example for all of us.*

CONTENTS

ACKNOWLEDGMENTS

We thank the individuals and families who contributed images for use in this project. Many dug into family scrapbooks and photo albums to help us develop what we hope is a compelling collection of images that illuminate the Japanese American experience and the community's wartime incarceration at Heart Mountain. The following institutions were particularly helpful: the Library of Congress, the National Archives and Records Administration, and the Japanese American National Museum. We also thank Densho: the Japanese American Legacy Project, the Buffalo Bill Center of the West, the American Heritage Center at the University of Wyoming, and writer and historian Frank Abe.

INTRODUCTION

For centuries, the Indigenous Apsaalooke nation called the oddly shaped peak between what became Cody and Powell, Wyoming, Heart Mountain because it looked like a buffalo heart. The name remained after white settlers backed by the US government moved into the area and forced the Apsaalooke into reservations to the north. It was here that the same government that forced the Apsaalooke away decided to place 14,000 people of Japanese descent, two-thirds of them US citizens, into a sprawling camp that immediately became the third-largest city in Wyoming.

This camp, euphemistically called the Heart Mountain Relocation Center, became home for 39 months for Japanese Americans from Los Angeles, San Jose, and San Francisco, California, and the Yakima Valley of Washington State. Over the course of World War II, prisoners from other parts of the West Coast cycled through Heart Mountain as the federal government and the nation coped with the shifting tides of the war and public opinion. In the fall of 1943, Japanese Americans from the Sacramento area and Washington who had been incarcerated in the camp at Tule Lake, California, were sent to Heart Mountain, while hundreds of Heart Mountain prisoners deemed disloyal were "segregated" at Tule Lake. The next year, hundreds of Californians and Hawaiians who had been living in the camp at Jerome, Arkansas, arrived at Heart Mountain after that camp closed.

These shifting groups gave Heart Mountain life. Despite being forced from their homes, often at the cost of their businesses and belongings, these incarcerated Japanese Americans built a community. Their children studied in camp schools; their elders played games, improved their English, and created artwork that has endured for the last 80 years. The high school football team, the Eagles, defeated teams from all but one of the neighboring towns. Farmers built two massive root cellars out of local timber to hold the produce grown while they made the high desert soil bloom. Considering the injustice and agony of their exile to this remote corner of Wyoming, the Heart Mountain prisoners created a success story.

That success, built on the endurance of the incarcerated people, masked considerable pain and trauma. Family ties frayed as generations no longer shared meals. People used to the privacy of their own homes had to share group showers and toilets without stalls. Young men who resisted being drafted into the Army from a prison camp were shunned by their community. Families with sons, husbands, and brothers fighting overseas dreaded the telegrams informing them that their loved one had either been wounded or killed in a French forest or on a dusty hillside in Italy. More than 550 babies were born in the camp hospital, while another 180 died in camp, often leaving their families without the elders who held them together.

The photographs contained here attempt to show the sweep of the experience of the Japanese Americans who spent at least part of the war years at Heart Mountain. Most of the camp's community traced their origins to the fishing villages and farms of southern Japan on either the main island of Honshu or the smaller island of Kyushu. After leaving Japan, they gravitated toward farming communities near San Jose or Washington's Yakima Valley or the burgeoning

communities of Little Tokyo in Los Angeles or San Francisco's Japantown. In camp, they scrambled not only to survive but to build a real town inside the barbed wire and guard towers that kept them confined. Thousands eventually relocated during the war to cities and towns around the country: Japanese American communities thrived in unlikely locations like Chicago, Detroit, and Seabrook Farms, New Jersey. Finally, most returned after the war to the West Coast, where they encountered a mixture of prejudice, hatred, and acceptance.

The Heart Mountain story does not end with the war or with the return of many of the prisoners to their former homes. Some of those imprisoned as children went on to lead the nation's oldest Asian American civil rights organization—the Japanese American Citizens League—while others entered politics and rose to its highest levels. Norman Mineta, who was 10 years old when he first stepped off the train at Heart Mountain, helped write the 1988 law that called for an official apology by the US government for the Japanese American incarceration and pay each surviving prisoner $20,000. Mineta's example inspired then-president George W. Bush to say after the 9/11 terror attacks that he would not subject Muslim Americans to the same discrimination that befell Mineta and his family after Pearl Harbor.

For years, there were few signs that anything had existed on the dusty plain between Cody and Powell. The federal government sold the former camp barracks for $1 to anyone who could haul them away. It was as if Heart Mountain was to be scrubbed from the nation's collective memory; however, enough former prisoners drove back to Wyoming to see if anything remained from their wartime incarceration that the residents began to notice. By the 1980s, there was a drive to designate Heart Mountain a national historic site. The Heart Mountain Wyoming Foundation was created in 1996, and by 2011, its members had led the creation of an award-winning interpretive center and museum on the former site. In 2024, the foundation opened the Mineta-Simpson Institute, a conference center and archive dedicated to spreading the values displayed by Mineta and former senator Alan Simpson in their public careers. The two men first met as Boy Scouts behind the barbed wire at Heart Mountain in 1943.

While cameras were initially prohibited in camp, many of the incarcerated brought them anyway. Photographs taken by these men and women make up the bulk of the collection here, while the War Relocation Authority employed talented photographers who captured images of life inside the camp and in the cities where relocated prisoners were trying to fit in. The result is a rich portrait of a community making its way through a shameful period in American history.

One

ORIGINS AND BUILDING
A COMMUNITY

The roots of most of the Japanese Americans who were incarcerated at Heart Mountain trace back to the southern part of the main Japanese island of Honshu, particularly around the port city of Hiroshima, and Kyushu, the southernmost of the four Japanese home islands. Between 1868 and 1924, about 125,000 Japanese immigrants came to the United States or Hawaii, which was an independent nation until 1898 and then a US colony. These first-generation immigrants were known as the Issei.

Many were young men who were usually not their families' first-born sons; they came to the United States looking for work as farmhands or fishermen. Others replaced Chinese immigrants, who were banned by the 1882 Chinese Exclusion Act, to work on the railroads and mines. Many were lured by books or pamphlets, such as *How to Succeed in America*, touting the United States as a land where they could earn enough money to return home and live in styles previously unimaginable to them. Once in the United States, however, these men faced virulent racism that increased after Japan defeated Russia in the 1905 Russo-Japanese War. The *San Francisco Chronicle* that year called the Japanese "the worst immigrant we have." Despite, these conditions, life in the United States was still appealing enough for them to either travel back to Japan to find wives or select women from books of those willing to immigrate to the United States and marry a stranger.

While Japanese immigrant communities rose across the West, the largest was in Los Angeles, where the Little Tokyo neighborhood near downtown was a thriving hub of Japanese businesses and artistic life. The second generation of Japanese Americans, known as the Nisei, strove to break out of the ethnic ghettoes that hemmed them in. They attended universities and became doctors, dentists, and lawyers. Future Heart Mountain prisoners lived in the agricultural communities of Santa Clara County, California, and the Yakima Valley of Washington State. About 600 of the future incarcerated population of Heart Mountain came from San Francisco's Japantown.

First Street in downtown Los Angeles was the epicenter of the Little Tokyo neighborhood. This view from 1933 shows some of the street's major businesses, with city hall in the background. (Japanese American National Museum.)

Weddings and funerals were major occasions in the Japanese American community before, during, and after the war. Here, mourners gather on April 15, 1941, at the funeral of Jiyauko Abe at the Los Angeles Baptist Church. (Japanese American National Museum.)

Japanese American flower growers prospered across the West Coast and Mountain states before the war. The Endow Nursery, shown here with its staff, was a Southern California institution and would remain in business after the war. (Japanese American National Museum.)

Zenroku Nagai, shown with his family, was a successful vegetable farmer in El Monte, California, which was just east of Los Angeles. California's Alien Land Law meant his farm had to be in the name of his eldest son, Tadashi. (Japanese American National Museum.)

Much of Little Tokyo's social activity consisted of gatherings of men who consumed large amounts of food, such as the event shown here. The government cast suspicion on the Japanese American custom of belonging to professional and social groups after the Pearl Harbor attack. (Japanese American National Museum.)

This group of Little Tokyo girls gathered outside in 1937 for a group picture. Photographer Chikashi Tanaka captured much of the community's social life before the war. (Japanese American National Museum.)

Yoshio Saito arrived in San Francisco in 1918 and lived with his older brother. He returned to Japan in early 1924, just before the passage of the immigration law that banned Asian migration to the United States, with his new wife, Fumi. They settled in San Francisco's Japantown, and Yoshio ran a store in Oakland. (Higuchi family.)

Iyekichi and Chiye Higuchi, shown here with their three oldest sons, from left to right, Takeru, James, and Kiyoshi, immigrated to the United States in 1915 and started farming. They eventually bought a 14.25-acre farm in San Jose that was actually owned by their two oldest sons, James and Kiyoshi. (Higuchi family.)

The Japanese American community in Santa Clara County, California, just south of San Francisco, lived on farms like this one in Mountain View. Hundreds of Japanese American families settled on farms in the country, growing row crops and berries. Many were forbidden by California's Alien Land Law from buying land in their own names, so they purchased it in the names of their US-born children. (National Archives and Records Administration.)

Ryohitsu and Tora Shibuya arrived in the United States in 1904. They eventually settled in Mountain View, California, where they lived with their six children, as shown here. Tora Shibuya died of cancer at the age of 51 in Heart Mountain on February 7, 1943. Ryohitsu returned to the family home, became a US citizen in 1954, and died in 1959. (National Archives and Records Administration.)

Two

FORCED REMOVAL

The attack by the Imperial Japanese government on the US naval base at Pearl Harbor was the most obvious reason for the incarceration of 125,000 Japanese Americans, but the conditions for this abuse of human rights started decades earlier. Federal Bureau of Investigation agents had built lists of community leaders who were quickly taken into custody and sent to a series of camps run by the Justice Department. The families of these men often had no idea what had happened to their loved ones.

Business owners posted pro-US signs in their windows to ward off vandals. Families removed or burned anything connected to Japan that had been in their homes. Some families contacted relatives living outside the West Coast to ask if they could live with them amid the growing instability at home.

After weeks of post–Pearl Harbor hysteria and pressure from racist military leaders, Pres. Franklin D. Roosevelt signed Executive Order 9066 on February 19, 1942. It authorized the military to designate an exclusion zone on the West Coast that would prevent suspected saboteurs or spies from living in areas near military bases. Although the order did not mention a specific type of individual, it was clearly aimed at Japanese Americans. Within weeks, signs were posted in cities informing Japanese Americans that they had two weeks to report to a series of assembly centers in California, Oregon, and Washington. Most future Heart Mountain prisoners would go to the centers at the Santa Anita racetrack in Arcadia, California, or the Los Angeles County Fairgrounds in Pomona, California.

The federal government and the newly created War Relocation Authority hired photographers to capture the images of the forced relocation. For some reason, they hired documentary photographer Dorothea Lange, who had taken some of the most iconic pictures of the Great Depression while working for the Farm Security Administration. Lange used her access to depict the tremendous dislocation and anguish of the Japanese American community. Her photographs were too depressing and honest to be released to the public; they sat unseen in government archives until 1965.

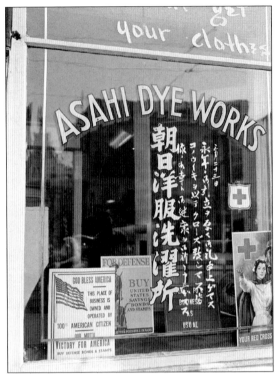

The Asahi Dye Works dry-cleaning shop in Little Tokyo, shown here, was operated by the Tanahashi family. Like many Japanese American businesses, they proclaimed their loyalty with a sign in the store window. Their son Kei was a leader in the local Boy Scout troop and would become the first Heart Mountain prisoner to die in combat in Italy. (Library of Congress.)

Many Issei living in Little Tokyo and other Japanese American neighborhoods did not read English, so they depended on bulletins posted in shop windows to learn about the latest news. (National Archives and Records Administration.)

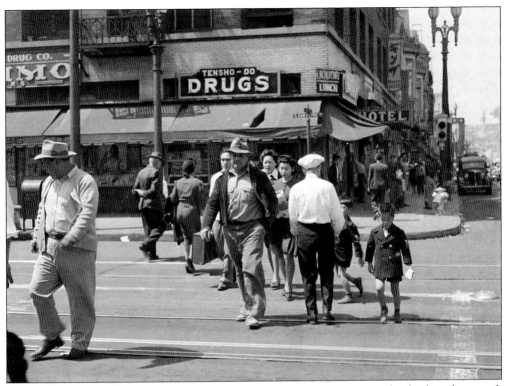

Pictured here, Little Tokyo residents hustle down the street in preparation for the forced removal. Within days after Pearl Harbor, Los Angeles mayor Fletcher Bowron fired Japanese Americans working for the city and made false claims about security risks. (Library of Congress.)

Two men load a panel truck with furniture in Little Tokyo as the forced removal gets underway. Many families lost all their possessions when the warehouses in which they stored were robbed or vandalized. (Library of Congress.)

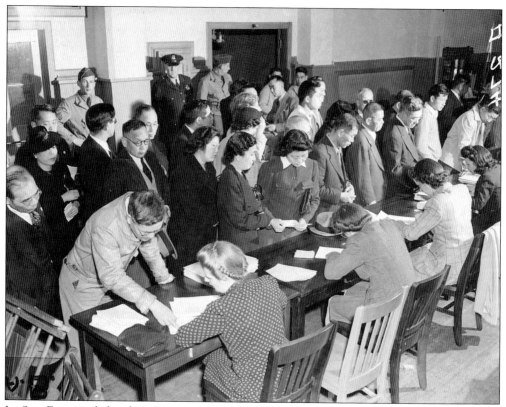

In San Francisco's bustling Japantown, residents registered for incarceration at the Wartime Civil Control Administration station. Most Japanese Americans in San Francisco were sent to the Tanforan racetrack and then to Topaz, Utah, but about 600 ended up at Heart Mountain. (National Archives and Records Administration.)

Students at the Raphael Weill Elementary School in San Francisco say the Pledge of Allegiance. Katsuichi "Willie" Ito, fourth from left, would be incarcerated at Topaz but would later become a Disney animator and illustrator of *Hello Maggie!*, a book written by former Heart Mountain prisoner Shigeru Yabu. (National Archives and Records Administration.)

The House Select Committee Investigating National Defense Migration, chaired by Democrat John Tolan of California, conducted hearings on the forced removal of Japanese Americans in February and March 1942. Here, John Abbott, a committee investigator, meets with a Santa Clara County farmer who just signed a lease for his farm to be rented by a White farmer. The Tolan Committee debunked claims that Japanese Americans in Hawaii had blocked emergency workers during the Pearl Harbor attack, but their findings did nothing to slow the hysteria that spurred the forced removal. (National Archives and Records Administration.)

Henry Mitarai, 36, is pictured here in one of his sugar beet fields on his mechanized farm prior to evacuation. His payroll ran as much as $38,000 a year. He employed dozens of farm workers and was one of the first farmers to mechanize his operations. (National Archives and Records Administration.)

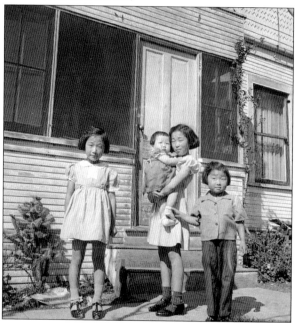

The Mitarai sisters—from left to right, Shirley, Elaine in the arms of Janet, and Patricia—stand in front of the family's home in Mountain View. The family would relocate in 1943 and 1944 to Richfield, Utah, where their father started a new farm. They would remain in Utah after the war, and Janet, now known as Jeanette Misaka, would eventually receive the Order of the Rising Sun from the Japanese government for her education work. (National Archives and Records Administration.)

Workers on Henry Mitarai's farm in Mountain View, shown here, relax after work with a cookout in the days before they were forced into assembly centers. Most of these men would end up at Heart Mountain. (National Archives and Records Administration.)

Sashichi Inouye, 64, lived with his daughter, Helen Mitarai, and son-in-law, Henry Mitarai, on their farm in Mountain View. Photographer Dorothea Lange captured this look of blank desolation on his face before the family was sent to Heart Mountain. During the war, Inouye relocated to Utah, where he remained for the rest of his life. (National Archives and Records Administration.)

While many of the Japanese Americans sent to assembly centers had sold their cars in the rush to leave their homes, some were able to drive. Here, these Southern California residents arrive at the Santa Anita racetrack in Arcadia, California, at the beginning of the incarceration. (Library of Congress.)

The first prisoners at the Santa Anita Assembly Center lived in stalls that once housed the Thoroughbred horses that raced on the track. At its peak, Santa Anita had 18,719 Japanese Americans living there. They came from all over California before dispersing to Heart Mountain and other camps. (National Archives and Records Administration.)

C-80

-6-42- Santa Anita -LINE-UP FOR LUNCH ~

Whether they lived in hurriedly converted horse stalls or barracks, the Japanese Americans incarcerated at Santa Anita had no way to prepare their own meals, so they had to line up for meals at one of the mess halls, shown here. Many remembered the terrible food that was nothing like they had at home. (National Archives and Records Administration.)

Prisoners and government officials noted that family ties began to fray in the assembly centers and incarceration sites. That erosion began in the assembly centers, where children often ate at different times and tables than their parents, pictured here. (National Archives and Records Administration.)

4-6-42- Santa Anita - LUNCH ROOM B-46

Perhaps the most famous horse to race at Santa Anita was the legendary Seabiscuit, which was the top money-winning horse of the 1930s. Here, prisoner Lily Okura poses with a statue of the horse later immortalized in bestselling books and movies. (National Archives and Records Administration.)

Military police patrol the fence around Santa Anita soon after the arrival of the first Japanese Americans forced from their homes. Emily Higuchi Filling, who was five when her family was sent to Santa Anita, remembered MPs (military police) blocking her older brother Kiyoshi from shaking hands with a friend who came to visit from San Jose. (National Archives and Records Administration.)

Japanese American nurses vaccinate children as they arrive at the Santa Anita Assembly Center. War Relocation Authority (WRA) records indicate many prisoners got sick when they arrived in the centers and camps. The overwhelmed medical staff at Santa Anita struggled to keep everyone healthy. (National Archives and Records Administration.)

Tasuke "Ike" Hatchimonji, peering from this bus window, grew up in a mainly White neighborhood. He remembered arriving at the Pomona Assembly Center with his family, including his twin brother Megumi "Mike," and seeing more Japanese Americans than he had in his entire life. (Japanese American National Museum.)

Prisoners from the Los Angeles area were sent to the Los Angeles County Fairgrounds in Pomona before going to Heart Mountain and other camps. At its peak, Pomona held 5,434 people, and most of them went to Heart Mountain. Many came from the Little Tokyo and J-Flats neighborhoods of Los Angeles. (National Archives and Records Administration.)

As in the other assembly centers, workers had to build barracks to house the prisoners quickly. The apartments lacked running water and had only rudimentary electrical systems that were often overloaded by the hotplates that many used to cook their own food. (Library of Congress.)

Three

BUILDING HEART MOUNTAIN AND ARRIVALS

The government had several criteria for locating an incarceration site, including a railroad connection and available water. Thanks to the one-time presence of Wild West entertainer William "Buffalo Bill" Cody, northwestern Wyoming had both. Cody had attracted tourists to the new town that bore his name, and he had created an irrigation scheme that would eventually be taken over by the federal government. Wyoming governor Nels Smith told federal officials that Japanese Americans who were sent to his state could not be allowed to roam freely or else they would be "hanging from every tree."

Some Wyoming towns recognized the benefits of having a camp near them. They envisioned having a pool of cheap labor to help complete irrigation projects or work on farms. In Park County, where the Heart Mountain camp would be located, reactions were mixed. The 1,900 residents of Powell were more welcoming than the 2,500 in Cody.

Construction on Heart Mountain started in June 1942. Men from Wyoming and the surrounding states flocked to the Cody area for jobs building the camp. The jobs paid twice as much as the Bureau of Reclamation was paying workers to complete the irrigation channel that led to the incarceration site, which meant the prisoners would have to finish the channel themselves. The first trainload of prisoners arrived on August 12, 1942. At its peak, Heart Mountain housed 10,767 Japanese Americans forced from their homes.

Wyoming governor Nels Smith sits with three soldiers in the offices at Heart Mountain. He told the federal government that Japanese Americans would be "hanging from every tree" if they were brought to Wyoming without being put in camps. He was not alone among regional governors in opposing the open movement of Japanese Americans in their states. Most urged the government to create camps surrounded by barbed wire and guards. Smith, a Republican, lost his bid for reelection in November 1942 to Democrat Lester Hunt, who was more sympathetic to the plight of the Japanese Americans incarcerated in his state. (Buffalo Bill Center of the West.)

Heart Mountain, shown here, got its name from the Apsaalooke (Crow) Nation, which thought it looked like a buffalo's heart when viewed from the south. It provided an iconic focal point for the more than 14,000 Japanese Americans who would be incarcerated there at some point between August 1942 and November 1945. (Okumoto collection.)

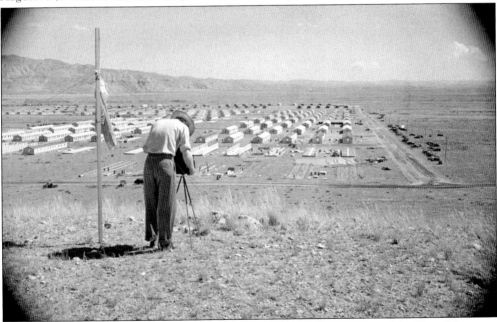

Jack Richard, editor of the *Cody Enterprise*, photographs the construction of the Heart Mountain camp. Workers from all over Wyoming and nearby states came to help build the camp. Richard helped the Heart Mountain prisoners publish their weekly newspaper, the *Sentinel*. (Buffalo Bill Center of the West.)

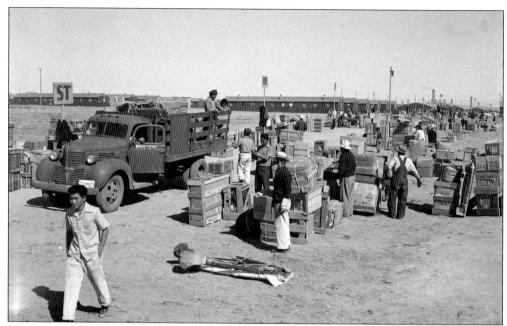

The trains that carried prisoners from the assembly centers to Heart Mountain also contained the few personal belongings they were able to bring with them. They were unloaded from the trains and piled alongside the track, where the belongings were taken by truck to the central part of the camp, sorted, and then distributed to the various barracks. (National Archives and Records Administration.)

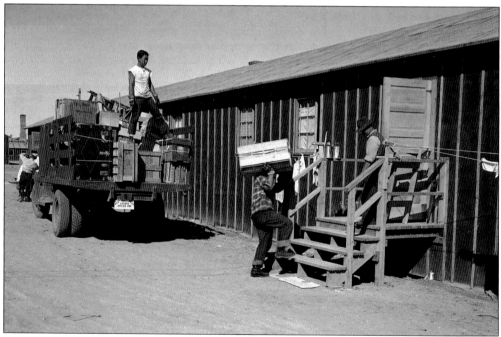

The crates were then delivered to the various barracks, where often-stunned prisoners were confronted with the stark reality of their new existence. Their barracks lacked indoor plumbing, insulation, or central heat. (National Archives and Records Administration.)

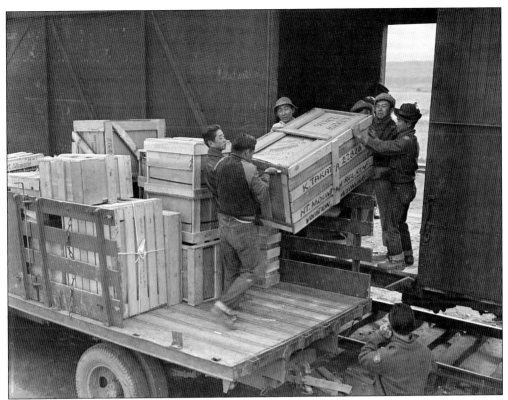

Government officials picked prisoners they considered reliable to help others acclimate to their new surroundings. They were on the first train to arrive on August 12, 1942. Here, they unload the belongings of the Takata family of Los Angeles, who arrived with their seven-week-old daughter on September 13, 1942. (National Archives and Records Administration.)

Heart Mountain and a guard tower loom in the background as crates of personal belongings are sorted in the central square at this relocation center. The owners had to identify their belongings and provide addresses for delivery of the crates to their barracks. (National Archives and Records Administration.)

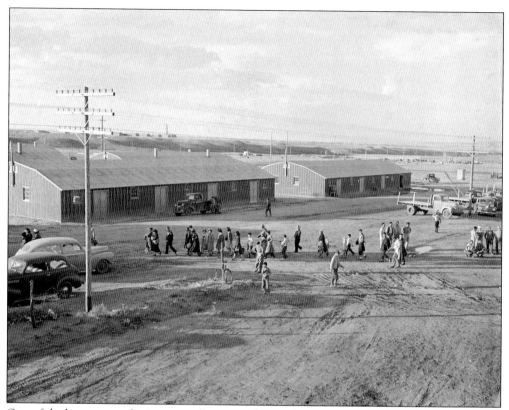

One of the last groups of prisoners walks across the warehouse area from the railroad platform to the registration office. Prisoners recalled being stunned by the dust and wind of their new home. Some cried when they realized this was where they would have to live. (National Archives and Records Administration.)

When the camp was completed, it was the third-largest city in Wyoming behind Casper and Cheyenne. Its population dwarfed nearby Cody and Powell. (Buffalo Bill Center of the West.)

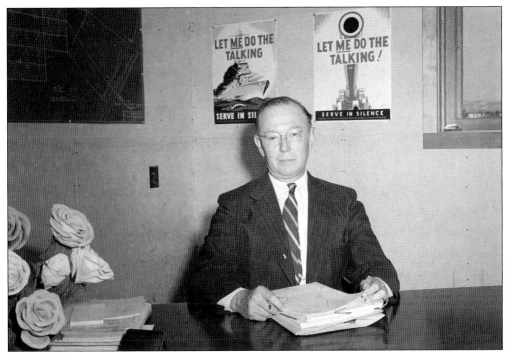

Guy Robertson was the second and final project director at Heart Mountain. In 1943, he said the camp was like "any normal community in interests and activities." Robertson was a friend of Wyoming governor Lester Hunt, who was elected in November 1942, and he often had to defend the prisoners from some of the overheated, racist rhetoric about conditions inside the camp. (National Archives and Records Administration.)

An agronomist and longtime official in the US Agriculture Department, Dillon Myer succeeded Milton Eisenhower as director of the War Relocation Authority. Myer said the goal of the relocation of Japanese Americans was to "scatter" them across the country and force them to assimilate into the larger society. (National Archives and Records Administration.)

8 showers + 4 tubs for 80 women

No privacy for women & children

Estelle Peck Ishigo was a Caucasian artist married to a Japanese American who chose to be incarcerated with her husband, Arthur, instead of remaining free alone in California. Both had been fired from their jobs almost immediately after the attack on Pearl Harbor. She led the arts program at Heart Mountain and captured images of life in the assembly centers and camp. She sketched portraits of daily life in Heart Mountain that were not often photographed. Here, she shows the spartan conditions inside the communal bathrooms in which prisoners had to shower together or take baths in rough tubs exposed to others. (Japanese American National Museum.)

Four

DAILY LIFE

When it was finished, the Heart Mountain camp was the third-largest city in Wyoming, after the capital Cheyenne and Casper. Although economically and emotionally devastated, the prisoners were determined to make their fate, however long it would last, as tolerable as possible. They created their own local government and court system under the watchful eye of the government administrators. They played board games and sports, took day and night classes, built a swimming home and ice-skating rink, and operated stores, barbershops, and beauty parlors. It was a regular town, except for the barbed wire surrounding it and the guard towers with machine guns facing in.

War Relocation Authority photographers circulated through Heart Mountain often as they attempted to put a positive face on the human rights abuse of incarceration. At first, prisoners were prohibited from using their own cameras, but many shot their own pictures to show what had happened to them and their families. All photographers showed the sweep of life inside the camp.

Despite all the attempts to make the most out of their new surroundings, prisoners faced deprivation and hardships. Their apartments initially lacked any insulation, which meant the harsh winds blew in the cold and dust. They never had indoor plumbing, and heat came only from a coal-burning stove in the middle of their apartments. Barracks apartments had no ceilings, so noise from one apartment would carry through the rafters into the next. Nevertheless, prisoners found enough privacy that 556 babies were born in the camp hospital.

Rev. Clyde Keegan performs a wedding ceremony at his home in Cody, Wyoming, for Kenichi Tanaka and Shizuko Kaku, the first couple to be married at Heart Mountain. According to the Petaluma *Argus-Courier*, she "arrived from California with only slacks to wear. She insisted the wedding must wait until she could obtain a dress." (National Archives and Records Administration.)

Scouting for boys and girls was a staple of Japanese American life before the war, and it was even more important during the incarceration. Here, Boy Scouts conduct a morning flag-raising ceremony at Heart Mountain. The communities from the various parts of California and Washington brought their troops with them. (National Archives and Records Administration.)

Most of the meal service in camp, shown here, was run by the prisoners, although the food rations were initially dictated by whatever food was available. Before the Heart Mountain farm was in operation in 1943, prisoners ate rough rations of inedible fish or canned tomatoes piled on rice. (National Archives and Records Administration.)

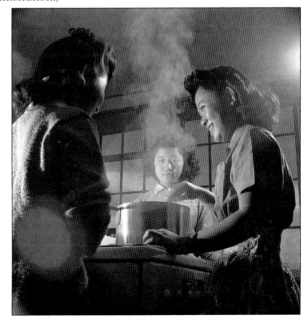

At right, 17-year-old Heart Mountain High School students Haruko Tachi, left, and Yaeko Hattori, right, try out a new recipe in the school's cooking class. (National Archives and Records Administration.)

Large funeral gatherings were common at Heart Mountain. Junichiro Fukuda was one week shy of his 50th birthday and living alone at Heart Mountain when he died on September 2, 1943. His wife was still living in Japan. His death certificate listed the causes as myocarditis and syphilitic aortitis. He was one of the 186 people who died while incarcerated at Heart Mountain. Most were buried in the cemetery at the camp, and their relatives removed their remains after the war. Three unclaimed prisoners are buried in the Crown Hill Cemetery in nearby Powell. (National Archives and Records Administration.)

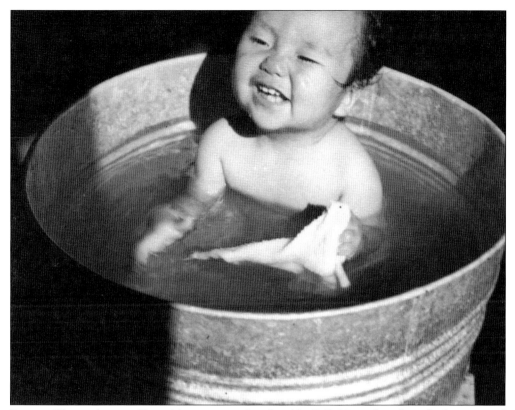

Dianne Oki was born at Heart Mountain on October 30, 1943. Here, she takes a bath in a metal bucket filled with warm water. Caring for children's hygiene was difficult when everyone had to share a bathroom and had no privacy. (Okumoto collection.)

Although the bath and shower facilities were limited, some prisoners managed to find small luxuries amid the hardships of life in camp. Takashi Sugiyama uses an improvised bathtub made from a sawed-off pickle barrel. He left on one of the last trains out of Heart Mountain bound for Chicago. (National Archives and Records Administration.)

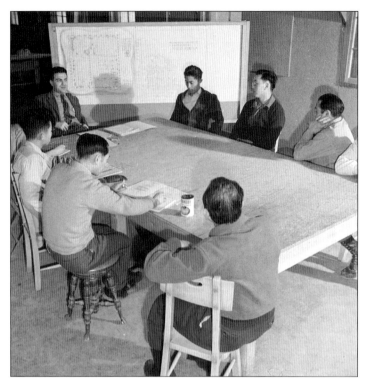

Although the government officials were firmly in control of daily life inside Heart Mountain, prisoners were allowed some say in their daily lives. Here, a group of the planning commission discusses proposed developments in the camp and makes recommendations to the departments. (National Archives and Records Administration.)

Each block of barracks had a manager elected by its residents. Here, Thomas Oki presides over a block manager meeting. Oki, who was at Heart Mountain with his wife, widowed mother, and infant daughter, was a Stanford University graduate in bacteriology who worked at the Hanford Laboratory before the war. (National Archives and Records Administration.)

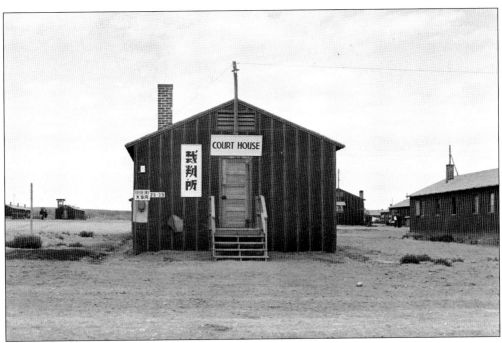

Heart Mountain prisoners voted overwhelmingly in September 1942 to create a court system consisting of seven judges and two alternates. Most of the judges were older Issei, except for Kyoichi Doi, a Nisei lawyer who had previously practiced in Los Angeles and Salt Lake City. Courtrooms were built in one of the recreation halls, and a prosecutor, public defender, court clerk, and secretary were picked from a group of the qualified incarcerated. (Okumoto collection.)

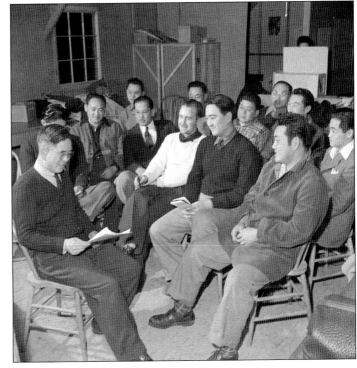

Donald Toriumi, a minister in one of the camp's Christian churches, acts as temporary chairman at a meeting of prisoners interested in forming a YMCA branch. Wilbur Maxwell, at center in the white sweater, was the visiting YMCA adviser. Toriumi was one of the most active Heart Mountain prisoners, often attending meetings, services, and parties for those relocating to other parts of the country. (National Archives and Records Administration.)

Fires were common in the wooden barracks, often because prisoners overloaded the rudimentary electrical systems with hotplates to cook their own food inside their apartments. Here, a fire crew assembles to put out a fire that started in one of the apartments. (Japanese American National Museum.)

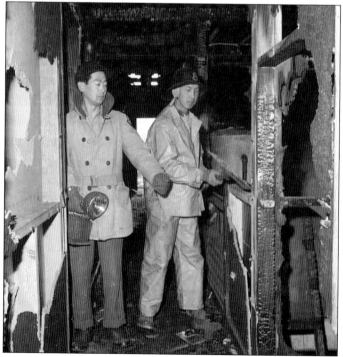

Here, two Heart Mountain firemen inspect the remains of a barracks to determine what caused the fire that devastated a family's apartment. Often, fire investigators recommended changes aimed at preventing more fires from destroying homes. (National Archives and Records Administration.)

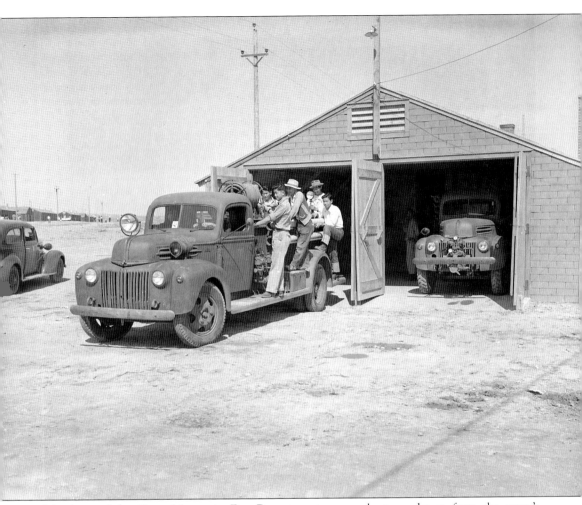

Members of the Heart Mountain Fire Department were volunteers drawn from the camp's population. They lacked the type of protective gear now associated with firefighting, but they quickly scrambled to go to fires that threatened to destroy what little the prisoners had taken with them to camp. Here, a truck company sets off on a practice run. Camp administrators urged prisoners to avoid anything that would set their homes ablaze. (National Archives and Records Administration.)

Eleven girls participated in the 1944 Bussei Coronation Ball, sponsored by the Heart Mountain Buddhist Church and the Young Buddhist Association. Winner May Inouye is seated on the throne and is joined by, from left to right, attendants Maye Wada, Kimi Tainaka, Toyo Taniguchi, Mickey Azeka, Helen Yamamoto, Sumie Hashimoto, Tazu Omori, Sally Shoda, Terry Higa, and Eiko Kinoshita. Inouye left Heart Mountain for college in Michigan, where she remained until retiring to Florida. She died at the age of 97 in 2021. (National Archives and Records Administration.)

Camp authorities and parents tried to make life at Heart Mountain fun for children. During Christmas 1943, about 4,000 children under the age of 18 celebrated. Here, a camp Santa Claus hands out presents. (Okumoto collection.)

Benji Okubo, whose mother was an artist in Japan, was a student at the Otis Art Institute in Los Angeles and a leader in the city's art movement before the war. Once incarcerated at Heart Mountain, Okubo became one of the camp's art instructors. He's teaching a night-school art class here and reviewing the sketch by a student. His sister Mine Okubo was incarcerated at Topaz and wrote and illustrated the influential book *Citizen 13660*. (National Archives and Records Administration.)

The incarcerated tried to preserve as many traditions as they could despite the pressure to assimilate. Here, young Emi Matsumoto performs a traditional Japanese dance. (Okumoto collection.)

Heart Mountain had its own swing band, the George Igawa Orchestra, pictured here, which played at events in camp and in surrounding towns. Igawa was well established before the war in Los Angeles, where he led a band called the Sho Tokyans. His band in Heart Mountain was made up of professional and amateur musicians. (National Archives and Records Administration.)

"Tubbie" Kunimatsu and Laverne Kurahara demonstrate some intricate jitterbug steps during a school dance held in the high school gymnasium. She sang with the George Igawa Orchestra and became a performer known as Tobi Kei after the war. (National Archives and Records Administration.)

Few Japanese Americans from California had been ice-skating before the war. There were few indoor rinks, and the California weather made outdoor skating impossible except for in the mountains. Firemen, such as this man, flooded flat sections of the campsite to create ice rinks for the prisoners to use. Hundreds of prisoners skated at a time, and many took the habit with them when they returned to the West Coast. (National Archives and Records Administration.)

Prisoners left their footwear behind as they tied on their skates for the ice rink. Kerry Cababa, whose parents were incarcerated at Heart Mountain, remembered her mother taking her skating in Hollywood after the war. "She learned to skate and had fun with it at Heart Mountain," she said. "I finally put two and two together. How else would a Nisei woman take her kids to a place in Hollywood where they skated?" (National Archives and Records Administration.)

47

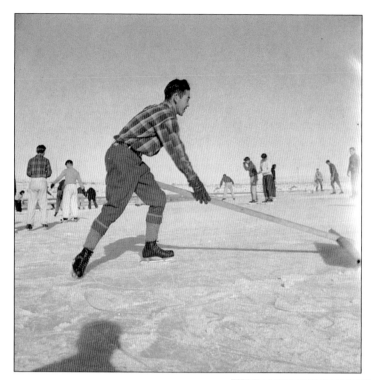

This volunteer ice keeper smoothes out the rink after another round of skating. Since prisoners were prohibited from leaving camp unless for work, finding recreation was difficult, which made attractions such as the ice rink more important. (National Archives and Records Administration.)

There were multiple playgrounds located across Heart Mountain to keep children occupied and entertained. Here, a young girl enjoys playing on a swing. Many WRA photographs were meant to show as normal a life as possible for the people who were unjustly incarcerated. (National Archives and Records Administration.)

Two small girls play with clay toys in the Heart Mountain nursery school. Memories of incarceration from those who were children are often more positive than those from older prisoners. The children remember fun activities and their friends. (National Archives and Records Administration.)

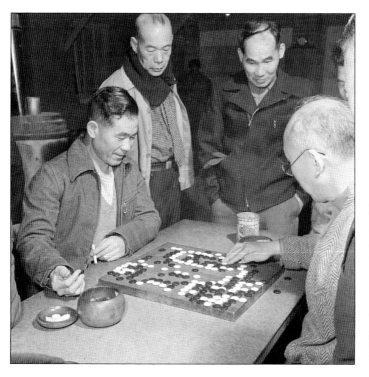

Older prisoners, such as these Issei men, played traditional Japanese games, such as Go. It was originally developed as a game of military strategy, and it was a popular pastime for the Issei. However, a six-year-old prisoner once defeated 13 older players in simultaneous games in camp. (National Archives and Records Administration.)

49

Shogi is a game that is also known as Japanese chess. It involves two people playing with pieces of differing capabilities. It was popular among Issei prisoners, such as the older man pictured here, who was startled by the WRA photographer who snapped this picture. "Although previously mumbling in Japanese, startled by the camera flash, the old gent let loose a typical American ejaculation," the original WRA caption said. (National Archives and Records Administration.)

Hideko Takehara, an 18-year-old Heart Mountain High School student shown here, attended Roosevelt High School in Los Angeles before she and her family were incarcerated. She moved to Cleveland in June 1945. By 1950, she was back in Los Angeles and working in a blouse factory. (National Archives and Records Administration.)

WRA photographers shot photographs of families enjoying what most Americans would consider a typical home. Here, Bill, Alice, and young Mike Hosokawa relax in their barracks. Bill was the editor of the *Heart Mountain Sentinel*, the camp newspaper. (National Archives and Records Administration.)

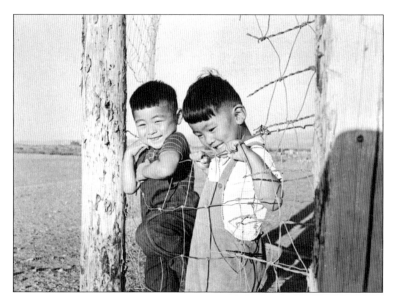

These two smiling boys, Donald Nagai (left) and Mike Hosokawa (right), lean on a barbed wire fence near their barracks. Donald was the son of Zenroku Nagai, who owned a farm in El Monte, California, and Mike was the son of *Sentinel* editor Bill Hosokawa. (Japanese American National Museum.)

Not every family photograph in Heart Mountain presented a happy home image. Here, the Furumura family of Los Angeles—from left to right, Aki, Jack, and Otokichi—sits in their apartment. Jack spent the first year of his incarceration in the Hillcrest tuberculosis sanitarium in La Crescenta, California. After the war, he returned to California, where he died at the age of 97 in 2013. (Okumoto collection.)

Ruzo Imafuji was rare among Issei in Heart Mountain because he was a naturalized US citizen through his service in the Army during World War I. He created Japanese decorations out of scrap lumber and put them throughout his barracks home. He told photographers he enjoyed his surroundings, which were reconstructed from memory of his early childhood. Imafuji was also a member of the American Legion, the veterans group active in pushing for the forced removal of Japanese Americans. (National Archives and Records Administration.)

David and Ruth Nitake and their daughter Judy relax in their apartment. He was a block manager, while she was an office attendant at the project hospital. Formerly of El Monte, California, David operated a rich orange nursery and ranch and owned his own land and home, which was cared for by a friend. After the war, they returned to Los Angeles, where he operated an insurance business. His granddaughter, Lia Nitake, is a board member of the Heart Mountain Wyoming Foundation. (National Archives and Records Administration.)

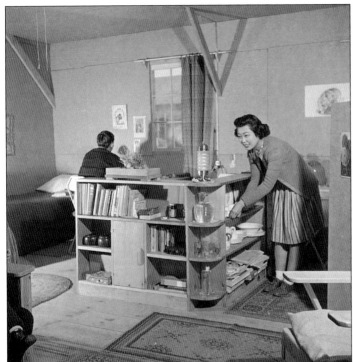

The home of Seiichi and Tsuji Nako looked like a testament to modern design. The family built its furnishings out of scrap and mail-order lumber to increase the livability of their Heart Mountain barracks home. Seiichi and Tsuji Nako moved to Philadelphia in 1944. Sachiko Nako, shown here, moved to Cleveland in 1943. (National Archives and Records Administration.)

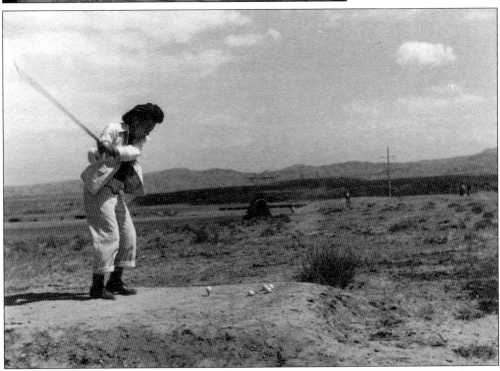

Heart Mountain prisoners had their own golf course and tournaments. Arline Taketa, who won the first women's tournament, takes a swing. She married a fellow prisoner, Fred Shikao Morita, on September 26, 1944, in Billings, Montana, and then relocated to New York. (Okumoto collection.)

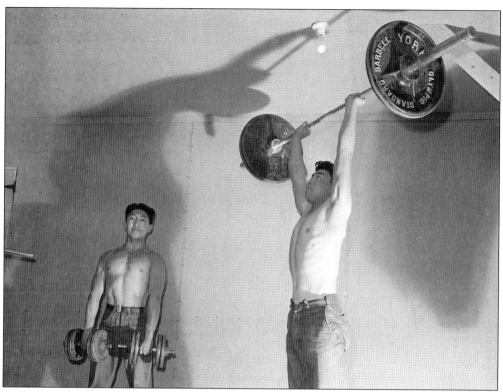

During its first week of operation, 250 students enrolled in the weight-lifting class at this relocation center. These young Nisei men look buff as they pump iron. The class instructors told the *Heart Mountain Sentinel* in October 1942 that many of the men enrolled in the class had to leave because they were harvesting sugar beets outside of camp. (National Archives and Records Administration.)

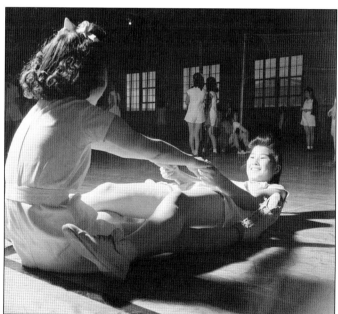

Women prisoners also tried to keep fit. Here, a couple of girls work out in the Heart Mountain gymnasium. (National Archives and Records Administration.)

Baseball was an important part of Heart Mountain life, and its teams drew from successful teams in California and Washington State. Best known among the camp teams was the one from Gila River, Arizona. Here, the Heart Mountain All-Star Team poses for a photograph before their game with the Gila River squad led by Kenichi Zenimura, a Hiroshima native known as the "Father of Japanese American baseball." The Gila River team made the 1,170-mile trip to Heart Mountain in September 1944 for a 13-game series. Most of the Heart Mountain players are wearing uniforms from local teams they played for before the war. (Japanese American National Museum.)

A Heart Mountain player slides into base during the series with Gila River. While competitive, the team faced the challenge of losing players to relocation or the military. (Japanese American National Museum.)

Five

MAKING A DESERT BLOOM

Heart Mountain developed an agricultural program that was the envy of the other War Relocation Authority camps. Many of the people incarcerated at Heart Mountain had been farmers in their previous homes in the Yakima Valley in Washington, Santa Clara County, California, and the remaining rural parts of Southern California. James Ito, the first farm director, had an agricultural degree from the University of California, while Eiichi Sakauye ran a thriving farm near San Jose before the war.

Their farming success was born of necessity. The first months of their incarceration featured mess hall rations that bore no relation to meals enjoyed by most Japanese Americans. A series of false stories in the *Denver Post* accused administrators of giving generous rations to Heart Mountain prisoners, which led Congress to call for reduced support for the camps. First, Heart Mountain prisoners had to finish the irrigation channel that led to the camp. Then they had to test the soil and weather patterns to determine what plants would thrive during the 90-day growing season. They planted the crops they thought would grow the best, and they watched diligently to ensure they survived. The entire camp population pitched in to harvest the crops, as school stopped so students could work in the fields.

The men and women of Heart Mountain also saved farms throughout the Mountain West after the area's young men left their farming jobs to fight the war. They harvested sugar beets and potatoes on farms in Wyoming and the surrounding states and cut timber in logging camps. While many of the residents harbored suspicions about their new Japanese American neighbors, they also realized their farms would have been devastated without the help of thousands of unjustly incarcerated young men and women.

Although access to water was one of the main criteria used to locate the camp at Heart Mountain, the irrigation line from the Shoshone Irrigation District to Heart Mountain was incomplete when the camp opened. Workers on the channel had left for higher-paying jobs building the camp. After they arrived in 1942, Heart Mountain prisoners had to finish the channel, shown here, which opened in early 1943. (National Archives and Records Administration.)

A prisoner watches from the bank of the Highline Ditch canal, the main irrigation source for the Heart Mountain farm. Access to this water enabled the farm to thrive. (National Archives and Records Administration.)

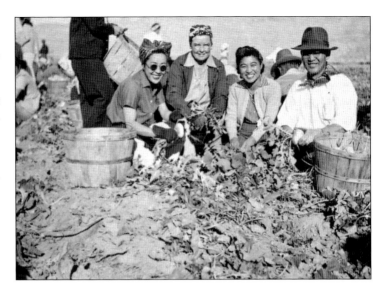

Heart Mountain prisoners and a camp administrator pull sugar beets from the fields at the camp farm in October 1943. From left to right are Peggy Kaoru Fujioka, Los Angeles; Virgil Payne, Cheyenne, Wyoming; Kimiye Nagai, Los Angeles; and Arthur A. Okado, Palo Alto. Fujioka and Payne led the camp's social welfare department. (Japanese American National Museum.)

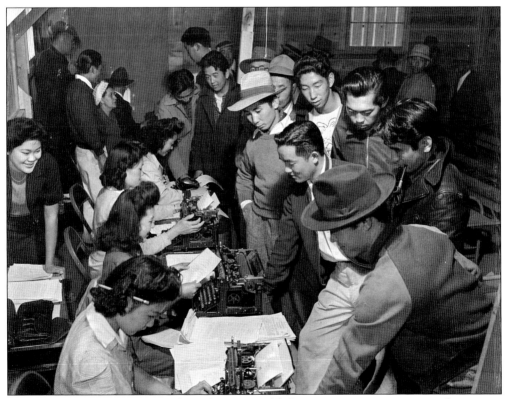

A labor shortage on farms throughout the West enabled Heart Mountain prisoners to leave camp to help harvest the sugar beet crop. Here, prisoners from Los Angeles register for temporary leaves to top beets in the fields of Colorado, Idaho, Montana, Oregon, and Wyoming. By the fall of 1942, about 1,200 Heart Mountain prisoners had left to work in the beet fields. (National Archives and Records Administration.)

A Montana farmer shows Heart Mountain volunteers how to pull and top sugar beets, which were a vital part of the war effort. Some Japanese Americans from Oregon managed to evade incarceration by committing to work on sugar beet farms in eastern Oregon. (National Archives and Records Administration.)

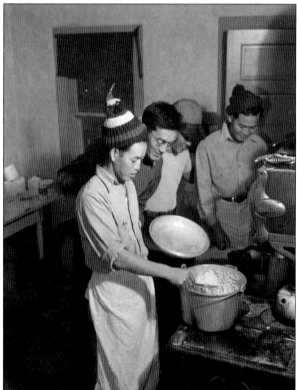

Topping sugar beets was hard work. Heart Mountain prisoners who volunteered for the job had little experience in the fields. They quickly worked up an appetite that was satisfied by the cooks supplying the farmers, such as the one shown here. (National Archives and Records Administration.)

False allegations of excess food stored in the camp warehouses, such as those shown here, led to calls to reduce food rations for the camp's prisoners and to pressure Heart Mountain farmers to produce more food. A warehouse worker fired by camp administrators told a reporter for the *Denver Post* that prisoners were hoarding food that was unavailable to Americans subjected to food rationing. (National Archives and Records Administration.)

The stark contrast between the cleared farmland and the scrubby fields next to the camp farm is clear in the photograph of the farm before the crops were planted. (National Archives and Records Administration.)

Eiichi Sakauye, seen here, was 30 when he first entered Heart Mountain. He had run farms in Santa Clara County before the war and was a natural choice to help run the camp's farm program. He and his fellow farmers would eventually grow enough produce to improve the types of food available to the prisoners but not during the first year of the incarceration, when the irrigation channel was unfinished. (National Archives and Records Administration.)

Shown on a tractor, Sakauye kept the farm program going during the last two full years of the incarceration. He was one of the first prisoners to leave camp once the government allowed them to return home. "I think we lost the best years of our lives," he said of the incarceration. (National Archives and Records Administration.)

Heart Mountain farmers had mechanized equipment to help them bring in their crops. The farmer pictured rides a bean thrasher late into the evening as he rushes to get the crop in before the autumn frost wipes it out. High school students were let out of their classes each year to help the farmers. (National Archives and Records Administration.)

In 1943, Heart Mountain farmers grew 2.1 million pounds of produce from 45 different crops on 638 acres of land. This Giant Pascal celery stood 29 inches high and was about the average size grown on the farm. Another staple crop was daikon, the Japanese-style white radish that glowed a radioactive yellow when pickled. (National Archives and Records Administration.)

Heart Mountain farmers raised cattle, pigs, and chickens to feed the camp's population. Manure produced by the livestock, shown here, was used to fertilize the farm's fields. (Okumoto collection.)

Because the Issei at Heart Mountain were technically citizens of Japan, they depended on the government of Spain, which was neutral in the war, to relay messages between the camp and their home country. In 1943, a shipment of goods from the Japanese Red Cross brought gifts to the prisoners, including the large containers of Kikkoman shoyu sauce shown here. More than 75 years after the incarceration, former prisoners recalled the day the Kikkoman arrived in camp. (Okumoto collection.)

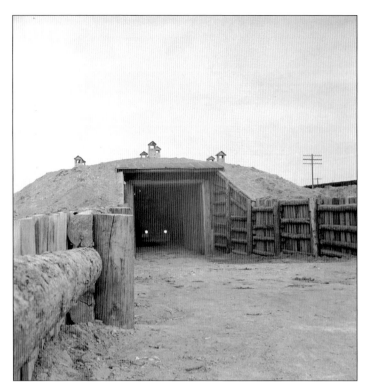

The success of the Heart Mountain farm meant the prisoners needed a place to store their produce. They designed and built two root cellars that were the length and width of a football field. The cellars, which used wood harvested from the forests near Yellowstone National Park, provided enough storage space to keep the crops throughout the winter. As seen here, each cellar was large enough for farmers to drive their trucks inside. (National Archives and Records Administration.)

The cellars needed vents, shown here, to allow air to circulate from the surface to the storage area. (National Archives and Records Administration.)

Six

WORK

Heart Mountain functioned like any other American city, except for the guard towers and barbed wire. The welcome bulletin sent by camp administrators to the prisoners shortly after their arrival said they faced "a long preparatory period before our labors begin to bear fruit. The entire nation will be looking on these camps as mighty experiments. The records that we establish here will no doubt play a great part in determining the manner in which we will return to civilian life after we have won this war. We are starting a new chapter in our lives here in the free, clean air of the West under fortunate and favorable circumstances. An able, sympathetic, and co-operative Caucasian staff is here to help us. The rest lies in our hands."

Prisoners worked in every type of job needed to keep a city of 11,000 people operating. Based on the type of jobs they had, prisoners were paid either $12 or $19 a month. Prisoners also worked in the local police and fire departments and as teachers and janitors in the local schools. Kunisaku Mineta, who ran an insurance agency in San Jose, became a captain of Block 24. Clarence Matsumura, a graduate of the University of California, Los Angeles (UCLA), became a sound equipment operator running movie cameras for the camp theater. He was also the supervisor for the camp zoo. Takashi Hoshizaki, who helped run his family's grocery in Los Angeles, worked as a surveyor to lay out the final stretches of the irrigation channel.

A critical part of the working community was the *Heart Mountain Sentinel*, the camp newspaper. It published a weekly edition, employed dozens of prisoners, and distributed a steady supply of messages aimed at keeping the incarcerated community working and productive. *Sentinel* editorials urged prisoners to keep working and avoid complacency.

Heart Mountain required four train carloads of coal each day to provide heat for the camp population. As seen here, crews climbed aboard the trains arriving at the station to pour coal into the trucks to be delivered to camp. (National Archives and Records Administration.)

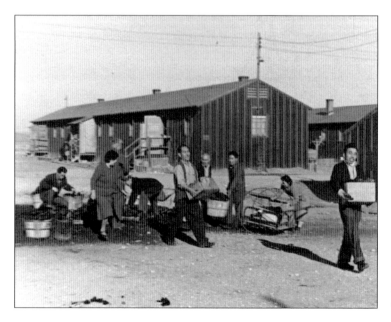

That coal was piled on the ground near the barracks, where prisoners had to collect it themselves and carry it back to their homes. The *Heart Mountain Sentinel* carried multiple stories about the need for prisoners to help gather and distribute the coal. (Okumoto collection.)

Many of the prisoners came from artistic backgrounds in Los Angeles, where they had studied at the Otis Art Institute or other schools. The War Relocation Authority created a shop to create and print posters for the war effort at Heart Mountain and at the camp in Amache, Colorado. Workers, such as those pictured, created posters of a large Navy gunship with the warning "Let Me Do The Talking." (National Archives and Records Administration.)

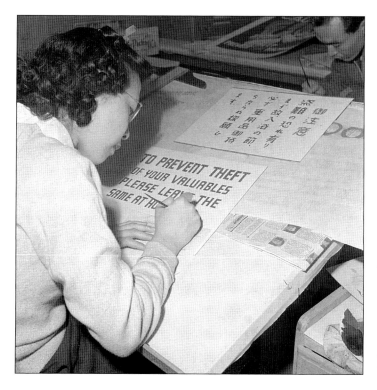

In this photograph, a young artist completes a draft of a general notice, including a Japanese language version for the prisoners who did not speak English. (National Archives and Records Administration.)

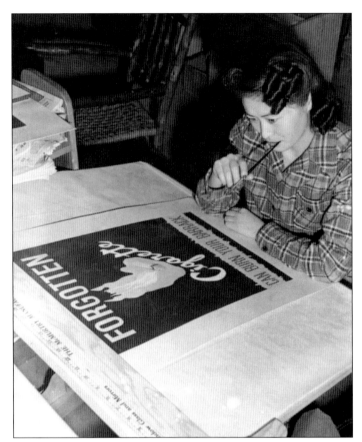

The poster shop was part of the larger propaganda effort for the war, as it produced campaigns urging fire safety and secrecy. This worker was part of the staff of residents working in the shop. (National Archives and Records Administration.)

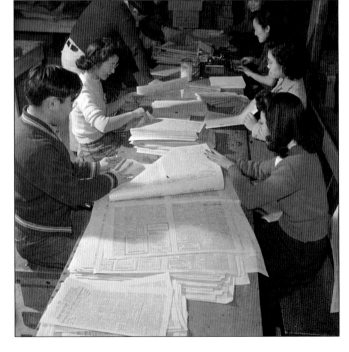

The reporting and editing staff of the *Heart Mountain Sentinel* scrambles to produce the paper on Friday night and Saturday morning. Editor Bill Hosokawa was originally set to go to the camp in Minidoka, Idaho, before authorities sent him to Heart Mountain to run the paper. (National Archives and Records Administration.)

The *Sentinel* staff folds the latest edition of the paper for distribution around camp. While it was widely acknowledged as the best of the camp newspapers, the *Sentinel* was a reliable conduit for the messages promoted by the WRA and the Japanese American Citizens League. (National Archives and Records Administration.)

The *Sentinel* included pages in Japanese for Issei prisoners who did not read English. It enabled the paper to reach a wider audience. Here, staff members reassemble a Japanese typewriter to be used for the Japanese edition. (National Archives and Records Administration.)

The incarcerated community eagerly picked up copies of the *Sentinel* when they were released each week. Some, such as the young man here, read the sports first, while others read the news or society pages. (National Archives and Records Administration.)

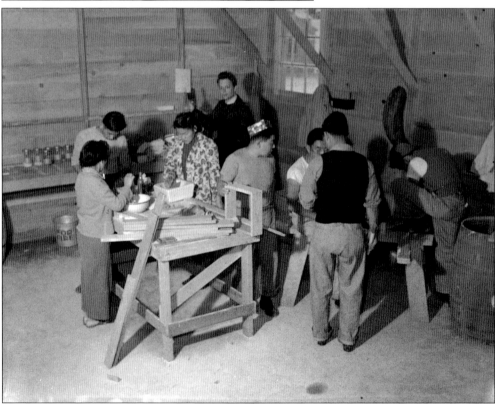

The *Sentinel* reported on plans to create a ceramics factory in the camp that would produce plates and other products to help the war effort. Here, prisoners working in the factory get their laboratory ready. (National Archives and Records Administration.)

One of the leading forces behind the ceramics program was Daniel Rhodes, who traveled to Heart Mountain after receiving his master's degree from Alfred University in New York. Here, he works with Minnie Negoro, who was an art student at the University of California in Los Angeles before the incarceration. (National Archives and Records Administration.)

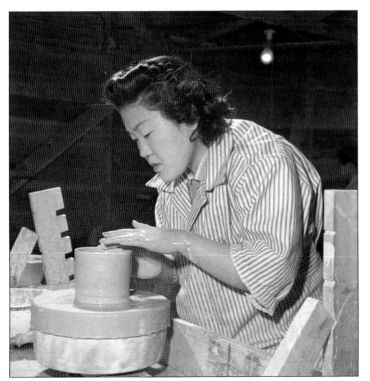

Negoro, pictured working with a potter's wheel, was an accomplished ceramics artist. She eventually relocated to Alfred, New York, and continued her art studies. After the war, she remained in the East and became the leader of the University of Connecticut's ceramics program. (National Archives and Records Administration.)

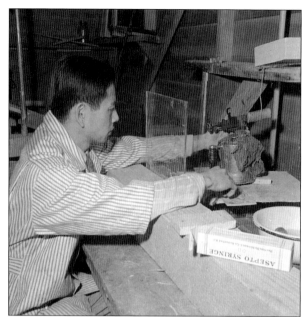

George Clem Oyama was a chemist in his father's cosmetics plant in Los Angeles before the war. It was his idea to create Heart Mountain's ceramics factory to provide jobs for the prisoners and dishes for the other WRA camps. Here, he analyzes the clay from the soil in the hills around Heart Mountain to determine its suitability. The plant was scuttled after the ceramics industry, which feared competition, and politicians led by Rep. Earl Lewis (R-Ohio) protested and forced the WRA to back down. (National Archives and Records Administration.)

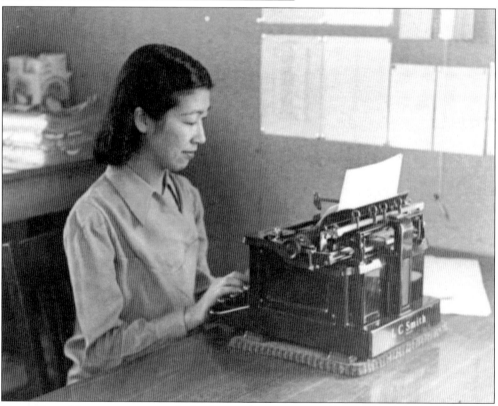

Many Heart Mountain prisoners had jobs in administrative offices. Yasu Yamaoka joined the YMCA staff. Seen here, Yasu had worked for the Blue Triangle Club in Los Angeles and came from the camp at Manzanar, California, with her husband, Isaac, in May 1943. They relocated to New York in April 1944. (Okumoto collection.)

Sam Kihara was an Issei who ran a barber shop in Los Angeles before the war. In Heart Mountain, as shown here, he picked up the same business. After the war, he returned to Los Angeles and resumed operating his shop. (Okumoto collection.)

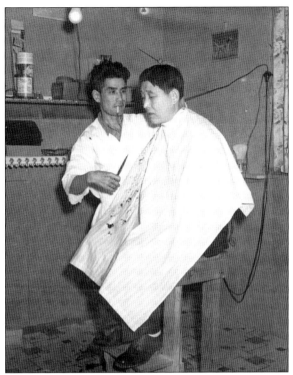

Stores inside Heart Mountain were run by the community enterprises department. They sold tobacco, sundries, and some canned and packaged groceries. Shown here is a store in operation. Heart Mountain was the only camp in which the community enterprises were not run by a cooperative, because of protests led by some vocal prisoners. (National Archives and Records Administration.)

Dr. Toshi Taro Tanaka had a dental practice in the heart of San Francisco's Japantown before the incarceration. California dentistry records show he received his certification in 1917 when he was 22. Here, he is filling the molar of one of his patients in Heart Mountain. (National Archives and Records Administration.)

Tanaka's colleague, Hisaichi Nakahara, practiced dentistry in San Jose before he was incarcerated at Heart Mountain. Seen here, he was head of the hospital's dental clinic. (National Archives and Records Administration.)

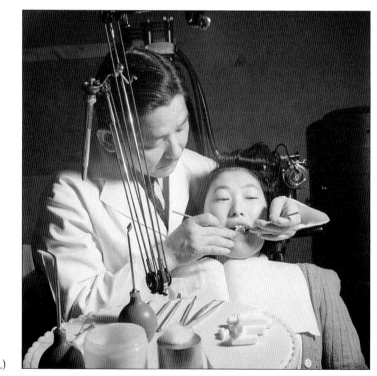

Nurse's aide Dixie Honda arrived at Heart Mountain in September 1943 from Tule Lake. Here, she is taking the temperature of a patient in the hospital. She was one of 100 nurse's aides at the hospital. She married in camp and later settled in Minnesota. (National Archives and Records Administration.)

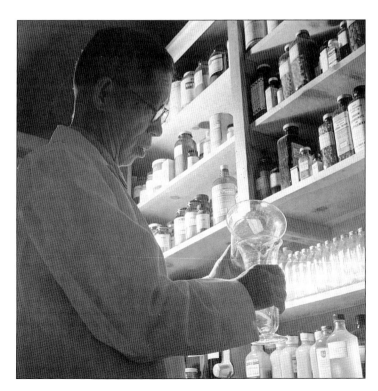

Kanzaburo Ishijima was a pharmacist in San Francisco before the war. He is preparing a prescription in the Heart Mountain pharmacy. His son, Teruo, also became a pharmacist and practiced in California. (National Archives and Records Administration.)

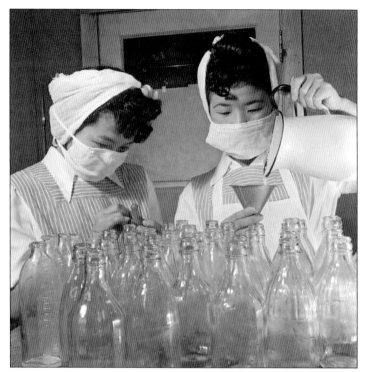

Ruth Uchida (left) and Haruko Nagahiro (right) worked in the hospital milk kitchen preparing baby formula. Uchida was the oldest of six children who lived with their widowed mother. Haruko left Heart Mountain in November 1943 for a job in Minneapolis. (National Archives and Records Administration.)

Optometrist Wright Kawakami examines the eyes of Al Tanouye before fitting him with glasses. Kawakami was a graduate of the University of California School of Optometry. He married while at Heart Mountain, relocated to Cleveland, and then returned to California to practice optometry for 50 years. (National Archives and Records Administration.)

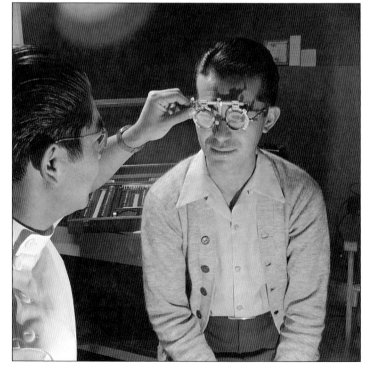

Seven

SCHOOL

Education was essential to the Japanese American community to help them climb upward in an often difficult, white-dominated society. While most Issei had jobs as farmers, fishermen, or shopkeepers, their children excelled in school, often attending some of the West Coast's most elite universities, such as UCLA, the University of Southern California, and Stanford. They became pharmacists, dentists, scientists, and doctors.

While they were in assembly centers, such as Santa Anita, school-age children attended class in the grandstands. Once they moved to Heart Mountain, they attended makeshift schools in the hastily assembled barracks at camp. Gradually, however, the schools began to improve. Incarcerated teachers supplemented the staff of Caucasian teachers who migrated to Heart Mountain to teach the student community. The schools were plagued by turnover, as many of the young teachers moved elsewhere for jobs that paid more money in less harsh conditions.

Many college-age students were forced to leave their universities during the forced removal. Thanks to the American Friends Service Committee, college students at Heart Mountain and the other camps had the chance to transfer to universities in other parts of the country. Some from Heart Mountain found refuge at state universities in Nebraska, Utah, and Wyoming, to name just three.

One of the highlights of Heart Mountain High School was the performance of its football team, the Eagles. During its two seasons of action, the team lost only once, a 19-13 duel with Natrona County High School in 1944. Their on-field success has been the subject of a successful book, *The Eagles of Heart Mountain*, and a documentary by NFL Films.

The first school buildings at Heart Mountain were overcrowded, as children sat jammed in small classrooms. Camp officials moved abandoned Civilian Conservation Corps (CCC) buildings to Heart Mountain for use as school buildings. Here, prisoners reassemble the buildings. By the end of the incarceration, 2,394 students attended the Heart Mountain schools. (National Archives and Records Administration.)

Workers rebuild one of the CCC buildings that augmented a barracks that was used for an elementary school. The CCC had an outpost in Cody as well as several inside Yellowstone National Park. (National Archives and Records Administration.)

The first school at Heart Mountain opened on September 30, 1942, and had 205 students in grades one through six in one barracks. Prisoners, pictured here, had to rush to make furniture for the schools and other buildings in the camp's woodworking shop. (National Archives and Records Administration.)

Most of the teachers at the Heart Mountain schools were White residents of the surrounding area, although some came from all over the West and even as far east as New Jersey. Some prisoners also taught at the school. Teachers gather in a dormitory room after a busy day of teaching. (National Archives and Records Administration.)

Ralph Forsythe was the principal of the Heart Mountain junior and senior high school. Here, he talks with students gathered outside his office. In an October 30, 1943, *Sentinel* article, Forsythe said Nisei students were extremely grade-conscious and dedicated. Former prisoners still remember the pressure they felt while in school. (National Archives and Records Administration.)

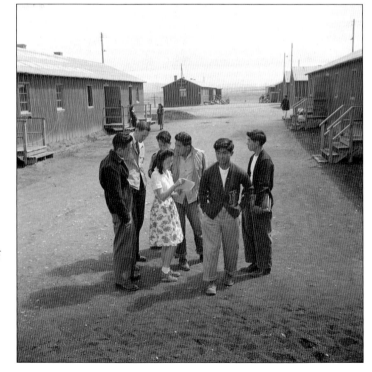

Students stand in the middle of the high school campus, which consists of several barracks clustered on the camp's dirt roads. The school buildings were originally designed as residential barracks. (National Archives and Records Administration.)

Joan Ritchie (left) and Janet Sakamoto (right) are learning how to make patches in the high school's sewing class. Joan's father, Ricardo Ritchie, was a mixed-race Japanese American who was born in Japan. Janet moved to Des Moines, Iowa, during the war and then returned to San Jose. Her older sister Grace married optometrist Wright Kawakami. (National Archives and Records Administration.)

Albert Saijo, pictured at left, was the editor of *Echoes*, the Heart Mountain High School newspaper. He discusses the upcoming issue with Hisako Takehara (center) and Alice Tanouye (right), who were the first-semester co-editors. Saijo became a poet after the war and an inspiration for the character of George Baso in Jack Kerouac's novel *Big Sur*. (National Archives and Records Administration.)

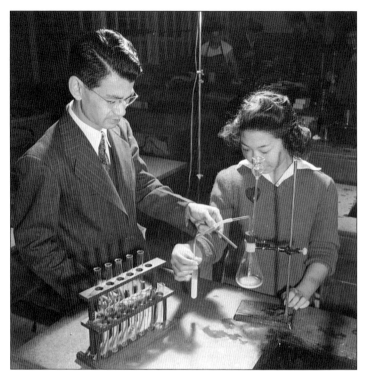

Kaoru Inouye was a graduate of the University of California at Berkeley with a chemistry degree. During his incarceration at Heart Mountain, he worked as a chemistry instructor in the high school before he entered the Army, where he was an intelligence officer. After the war, he worked as a research chemist in the defense industry and an environmental laboratory. Here, he shows student Sumi Tamura a step in a chemistry experiment. (National Archives and Records Administration.)

Harry Ishigaki conducts a chemistry experiment in class. He relocated with his family to the Seabrook Farm in Bridgeton, New Jersey, where he graduated from high school. After the war, the family returned to their hometown of San Jose. (National Archives and Records Administration.)

Parents started their young children at the Heart Mountain nursery school, which enabled some of them to work in various jobs. The photograph shows the lack of amenities in the school and the bare wooden floors of the barracks. (National Archives and Records Administration.)

Three members of the Heart Mountain High School student government—from left to right, Janice Shiota, Ted Fujioka, and Shogo Iwasaki—look over a poster advertising the senior play. Fujioka was the first student body president of the high school. He enlisted in the Army soon after graduation and died fighting in France. (National Archives and Records Administration.)

Thousands of Japanese American college students on the West Coast were forced from school during the incarceration. Thanks to the American Friends Service Committee, which created the National Japanese American Student Relocation Committee, they were able to leave the camps and study elsewhere. One sanctuary was the University of Nebraska, where three students—from left to right, Cromwell Mukai, from Topaz; Marie Yamashita, from Heart Mountain; and Joe Nishimura—from Manzanar—were among the 104 Japanese American students who attended the university. They are shown leaving the university's stadium. By July 1943, a total of 92 college students from Heart Mountain relocated to various universities. Yamashita graduated from the university in 1946. (National Archives and Records Administration.)

Sports were important for boys and girls in the camp schools. Their teams played schools from outside camp, such as in this game, between the Heart Mountain High School girls' basketball team and that from nearby Powell High School. The Heart Mountain team won 32-24. (National Archives and Records Administration.)

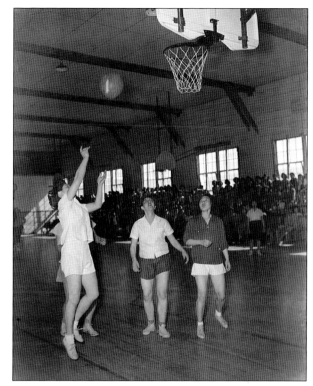

Although they were usually smaller than the opposition teams they played from outside the camp, the Heart Mountain Eagles lost only one of the games they played during the 1943 and 1944 seasons. Outside of the school games, members of All Stars and Jack Rabbits teams would play each other, such as in this game. (National Archives and Records Administration.)

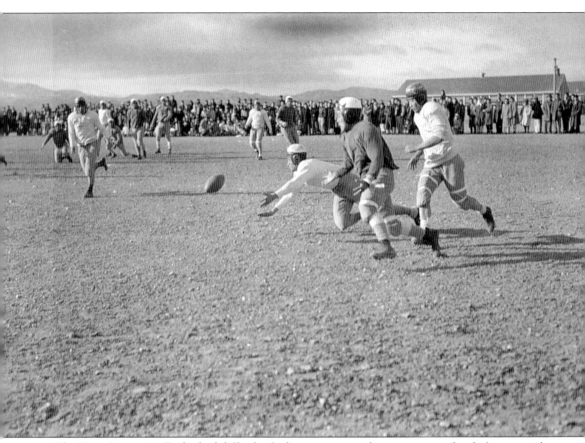

The Heart Mountain Eagles had difficulty finding opponents, because many schools from outside the camp were reluctant to add them to their schedule. When they did, they had to play inside Heart Mountain surrounded by a sea of Japanese American faces, which some of the opponents found unnerving. The Eagles' one loss in 1944 came at the hands of the team from Casper, which featured a 210-pound fullback, Leroy Pierce, who outweighed each of the Eagles players by at least 60 pounds. In this game between the All Stars and Jack Rabbits, an attempted pass is fumbled and pounced on by a member of the opposing team. (National Archives and Records Administration.)

Eight

RELOCATION

Dillon Myer, the head of the War Relocation Authority, believed the forced removal of Japanese Americans from the West Coast enabled the government to scatter the community throughout the country and to force its members to assimilate into a white-dominated society. He exploited the labor shortages that affected most communities throughout the country to encourage Japanese Americans to leave the camps for jobs in the East and the Midwest. The WRA had 42 offices around the country to facilitate relocation by helping the incarcerated find jobs and housing. The WRA's chief employment officer said the authority was just running a series of temporary boardinghouses for West Coast Japanese Americans until they could find jobs in other parts of the country and that Heart Mountain residents needed to step up their attempts to leave camp. Prisoners in Amache, Topaz, and Minidoka were relocating faster than those from Heart Mountain.

The *Sentinel* published dozens of articles touting the low cost of living in Midwestern cities, the availability of civil service jobs in Washington for Nisei, and the availability of help for Nisei young women who wanted to move to Chicago, one of the major hubs for Japanese American relocation. Often, the *Sentinel* more closely resembled a brochure for a Midwestern chamber of commerce than a newspaper.

By the middle of 1943, the relocation arm of the War Relocation Authority found another gear. "More and more outside offers continue to flood the employment office," said an August 19, 1943, supplement of the *Sentinel*. Most of the available jobs were in the industrial Midwest, where the same labor shortage that empowered women in the workplace, giving rise to Rosie the Riveter, had created numerous opportunities for Japanese Americans.

Relocation involved more than just prisoners leaving Heart Mountain for cities around the country. In June 1944, the camp in Jerome, Arkansas, closed, and at least 400 of its residents, seen here, traveled by train to Heart Mountain. (Okumoto collection.)

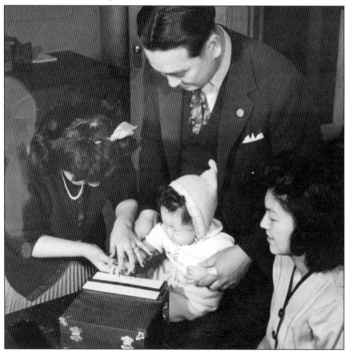

Relocating required each adult prisoner to fill out a loyalty questionnaire that helped authorities determine if it was safe to let the prisoner leave Heart Mountain. Once approved, they had to be fingerprinted and registered. Here, young Robert Kodama Jr. is fingerprinted by Misako Tomita while his parents, Robert and Ann, look on. (National Archives and Records Administration.)

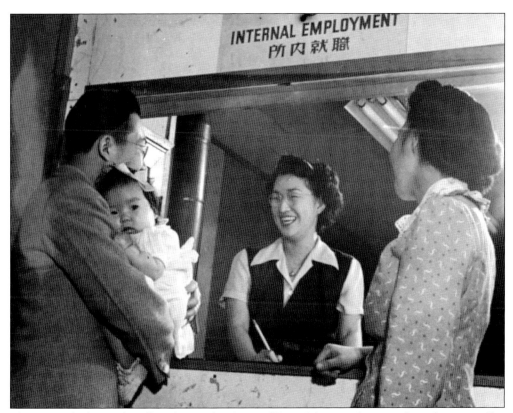

INTERNAL EMPLOYMENT
所内就職

Thomas and Gloria Oki talk with Haruko Fujita of Heart Mountain's internal employment office as they clear all government property as the Oki family prepares to leave for Cleveland. Thomas Oki is holding their daughter Dianne, who was born in Heart Mountain. (National Archives and Records Administration.)

Robert and Ann Kodama, who is holding Robert Jr., board the bus at the Heart Mountain depot for their trip east to Cincinnati. Robert Kodama was an office manager before the war in Los Angeles, while Ann Kodama worked in a state government office. (National Archives and Records Administration.)

Thomas, Gloria, and Dianne Oki board the bus east to their new home in Cleveland. Couples such as the Okis who were active in community life in Heart Mountain were often among the first to receive clearance to relocate. Thomas Oki was a member of the Heart Mountain council. (National Archives and Records Administration.)

Fujiye Fujikawa was a stalwart of the Heart Mountain poster shop before she relocated to Philadelphia, where she did a similar job for an advertising agency. She returned to Los Angeles after the war, married, and remained in steady contact with fellow artist Mine Okubo, who was incarcerated at the Topaz, Utah, plant and whose brother Benji was an art teacher at Heart Mountain. (National Archives and Records Administration.)

Iwahei Frank Inui left Heart Mountain for Baltimore in March 1944 and found work as a presser in a laundry. Before the war, Inui and his family lived in Los Angeles, where he ran a dry cleaning business and then owned his own grocery store. He had lived throughout the West, including in Utah, before then. Inui and his family moved to Baltimore because his brother, Dr. Frank Inui, was on the staff of the Johns Hopkins Hospital there. (National Archives and Records Administration.)

Frank Higa (left), his sister Shizu, and his brother George sit in the grocery store he opened in Washington in September 1944. He first relocated to Washington in October 1943 to work as a laboratory technician. The store was successful enough for the entire Higa family to move to Washington from Heart Mountain. After the war, they returned to California. (National Archives and Records Administration.)

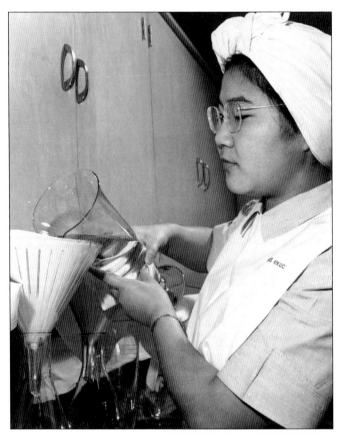

Riyeko Kikuchi, formerly of Tacoma, Washington, and Heart Mountain, makes intravenous fluid while in training as a nurse at the Kansas City General Hospital in Missouri. During her training, she was a member of the Army Cadet Nurse Corps. After the war, she returned to Washington, married, and raised a family. (National Archives and Records Administration.)

Kenji Sumi, an Issei pictured here, worked with his wife as domestic workers in San Francisco before they were forced from their home to the Pomona Assembly Center and then Heart Mountain. The Sumis relocated to New York, where he found a new job as a silk screener for Meissner Colorcrafts. They shared an apartment with Yachiyo Sumi's sister June Okubo, who was a secretary. (National Archives and Records Administration.)

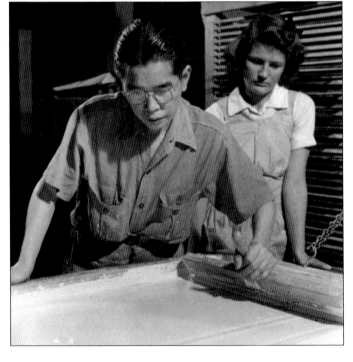

Thomas Oki relocated from Heart Mountain to Cleveland, where he is working at the Neo Mold Co., spraying molten metal on a piston head for the F-47 Thunderbolt fighter. Although Japanese Americans were ostensibly too great of a security risk for them to live on the West Coast near military installations, many prisoners from Heart Mountain and other camps relocated to work in defense jobs around the country. Oki and his family returned to California after the war, and he ran a clothing company. He died at the age of 97 in 2014. (National Archives and Records Administration.)

Ralph Kawabe relocated to Des Moines, Iowa, in 1945 after first moving to Utah. Pictured with laundry owner E.R. Montgomery, he learned how to press clothing. He and his family returned after the war to Los Angeles, where he died in 1996 at the age of 93. (National Archives and Records Administration.)

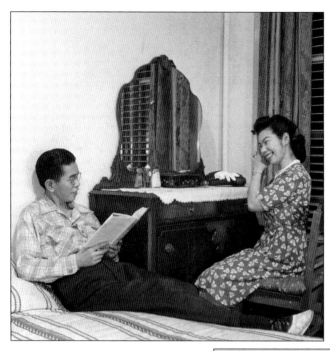

Kenji and Yachiyo Sumi relax in the bedroom of the furnished apartment in New York they share with June Okubo, Yachiyo's sister. They rented the furnished apartment by answering an advertisement in a New York newspaper. Many Japanese Americans who relocated had difficulty renting apartments from owners who did not want to rent to them. The WRA photographers went to great lengths to show former prisoners who had managed to find new lives outside of the camps. (National Archives and Records Administration.)

Kumazo Ambo, an Issei, is pictured at work in the San Rae Gardens in Dayton, Ohio. Ambo, his wife, and their son lived in Goleta, California, before the war and relocated to Dayton in April 1944. They were later joined by another son in Dayton. After the war, the family lived in Michigan before returning to California, where Kumazo Ambo died in 1969. (National Archives and Records Administration.)

Hiromu Komori, left, formerly of Pasadena and Gila River, and Hitoshi Fukui, right, formerly of Los Angeles and Heart Mountain, are shown operating a Logan lathe at the Aetna Manufacturing Co. in Cleveland. Both men were veterans of World War I. Before the war, Fukui owned the Fukui Mortuary, which was then and still is the preeminent funeral home in the Los Angeles Japanese American community. (National Archives and Records Administration.)

Three Nisei students sit at dinner with Caucasian students and faculty members of the National Training School in Kansas City, Missouri. The young woman sipping tea is Toshiko Nagamori, who was formerly from Hollywood before being incarcerated at Heart Mountain. She would marry James Ito, who helped run the Heart Mountain farm program before leaving for the Army. Their son Lance Ito became a Los Angeles County Superior Court judge. (National Archives and Records Administration.)

Frank and Chiyo Matsuuchi left Heart Mountain to work at the Old Lyme Inn in Old Lyme, Connecticut, only a few miles from the shore. Many Heart Mountain prisoners left camp to work in the hospitality industry around the country. Many hotels and resorts placed ads in the *Heart Mountain Sentinel* looking for help. The Matsuuchi family, which was originally from Los Angeles, would return to California after the war. (National Archives and Records Administration.)

Nellie Takamoto, shown here, relocated to Philadelphia from Heart Mountain in June 1944. She is collating medical textbooks in a Philadelphia publishing house. A 1942 graduate of Placer Union High School in Auburn, California, she was originally incarcerated at Tule Lake and then moved to Heart Mountain in September 1943 as part of the segregation of "loyal" and "disloyal" prisoners. One of her sisters relocated to Cincinnati, while a brother served in Italy with the Army. (National Archives and Records Administration.)

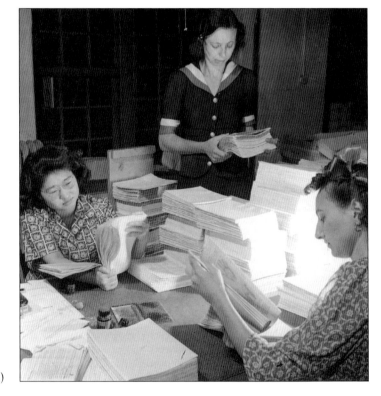

Torao Suyehiro (center) and Shoichi Akutagawa (right) are shown being interviewed in the personnel relations department of Seabrook Farms and the Deerfield Packing Corp. in Bridgeton, New Jersey, by Ellen Ayako Nakamura, a liaison officer between the evacuees and the management at Seabrook Farms, where over 400 former prisoners found jobs. (National Archives and Records Administration.)

The Chicago WRA supervisor, Elmer L. Shirrell, welcomes five former prisoners who relocated to Chicago; from left to right are Mits Tanigawa from Heart Mountain; Raymond Shimizu from Heart Mountain; H. Kadoyama, a greenhouse worker from Kent, Washington, and Tule Lake; Yoe Nishi from Nyssa, Oregon; and Frank Okazaki from Heart Mountain. Chicago became the unofficial Japanese American capital of the United States during the war. (National Archives and Records Administration.)

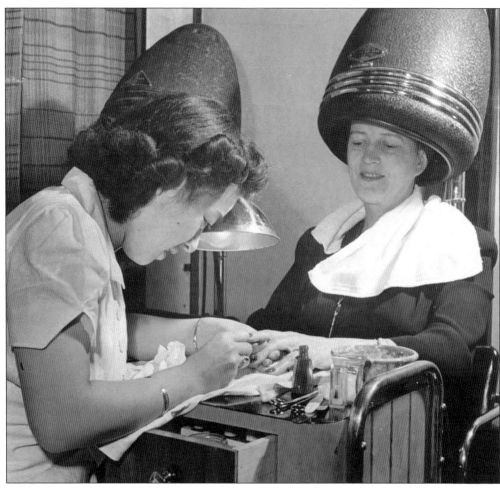

Mary Lucy Nakamura was a beautician in a Seattle salon before the war. Originally from Yakima, Washington, she relocated in 1943 to Chicago, where she resumed working in a salon. After the war, she married and lived in Utah before returning to Washington, where she died at the age of 91 in 2010. (National Archives and Records Administration.)

Tsuneyoshi Manabe, an Issei shown here, was a divorced man who lived alone at Heart Mountain before he relocated in June 1944 to Omaha, where he worked for John Murray, a prominent local photographer. Manabe told the WRA he was happy to be working as a photographer. He remained in Omaha for a few years after the war before returning to California, where he died in 1962. (National Archives and Records Administration.)

Rev. Sankin Sano is shown here with his wife, Chiyeko, nine-year-old boy Toshio, and their latest arrival, Irwin. This picture was taken at the Central Baptist Seminary in Kansas City, Kansas, where Sano was studying for his master's degree in theology. Sano, who was born in Tokyo in 1907, was a rare Japanese immigrant who arrived in the country after the passage of the 1924 immigration law that banned almost all immigration from Asia. He became a naturalized citizen in 1953, and the family remained in Kansas City. (National Archives and Records Administration.)

The Watanabe and Hisatomi families lived in Los Angeles before they were incarcerated at Heart Mountain. They relocated in early 1943 to Cincinnati, where they shared a large home. Barbara Watanabe Batton, who is being held by her father, Henry, in the photograph shown here, remembered that her family moved to Cincinnati because her father's two younger sisters lived there. Her uncle George Abe was a medical student there. Their trip to Cincinnati took 40 hours by train. (National Archives and Records Administration.)

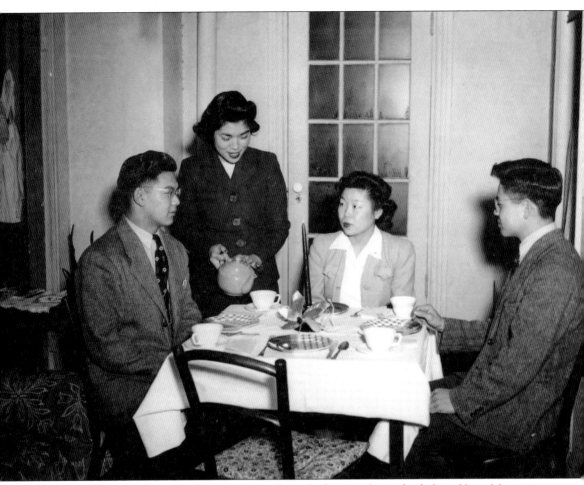

Yoneko Watanabe (left center) and Fujiye Fujikawa (right center) were both from Heart Mountain and shared an apartment. Here, they share a Sunday night dinner with the Koiwai brothers, Karl (left) and Henry (right), who relocated to Philadelphia from the camp in Minidoka, Idaho. Yoneko was born in Japan in 1917 and immigrated with her family in 1924, just as the harsh US immigration law was taking effect. She was a medical secretary at local hospitals, while Fujiye worked in an advertising agency. Karl Koiwai was a medical student, while his younger brother Henry studied at Temple University. Karl became a medical doctor and remained in Philadelphia, while Henry returned to the West Coast. (National Archives and Records Administration.)

Nine

SERVICE AND RESISTANCE

Although Japanese Americans had served in the military during World War I and had enlisted before the attack on Pearl Harbor, they were banned from serving until 1943. The Japanese American Citizens League, which had given its tacit approval to the incarceration, lobbied to enable Japanese Americans to serve in the Army. The military relented at the beginning of 1943 and enabled Japanese Americans, including those incarcerated in the camps, to enlist. The response in Hawaii was overwhelming; almost 10,000 Japanese Americans from the territory enlisted. In Heart Mountain, however, the response was underwhelming. Only 38 young men enlisted. They included Ted Fujioka, the first student body president of Heart Mountain High School, and Fred Yamamoto, a writer for the *Heart Mountain Sentinel*. He told his mother "that if he were killed, he knew that he would be doing the right thing for us and for his country," so she gave her permission.

The government created a loyalty questionnaire to screen out potentially subversive elements from the Army. The questionnaire was extended to all prisoners who wanted to relocate to different parts of the country. It was routine except for two questions—Nos. 27 and 28—which attempted to determine if the respondent was willing to serve in the military and foreswear any allegiance to the Japanese emperor, government, or any government. Anger and confusion over those questions led thousands to answer No to both, which triggered a program known as segregation in which the so-called disloyal prisoners were shipped to the camp in Tule Lake, California.

In 1944, the military decided to expand the draft to include Japanese Americans who were incarcerated. That sparked the creation of the Fair Play Committee, a group opposed to drafting young men who were imprisoned by their own government for the crime of being Japanese. Eighty-five men from Heart Mountain eventually refused to show up for their induction physicals. They were convicted after two trials in 1944 and 1945 and sentenced to federal prison. Pres. Harry Truman pardoned them on December 24, 1947.

Hitoshi "Moe" Yonemura was a graduate of the University of California, Los Angeles, and was the head yell leader for the school football team, a rarity among Japanese Americans. He was a member of numerous UCLA honor societies and of the Army's Reserve Officer Training Corps (ROTC). His ROTC experience helped him become a lieutenant with the Army's 442nd Regimental Combat Team, the all-Nisei unit. Yonemura died in April 1945 fighting in Italy and received a posthumous Silver Star. (National Archives and Records Administration.)

Yonemura was a popular speaker at Heart Mountain with draftees and potential enlistees. Here, he talks with, from left to right, draftees Mason Funabiki, Masao Higashiuchi, and Albert Tanouye. (National Archives and Records Administration.)

Clarence Matsumura was born in Wyoming while his father worked on the Union Pacific Railroad. The family moved to Los Angeles, where they ran a grocery store. He attended UCLA before he was incarcerated at Heart Mountain. He left Heart Mountain to study at the University of Cincinnati, where he was drafted. While serving with the 522nd Field Artillery Battalion, part of the 442nd Regimental Combat Team, he rescued Jewish workers from a forced labor camp outside the Dachau death camp. (Matsumura family.)

Ben Kuroki, shown here, was the son of an Issei farmer in Hershey, Nebraska. Shortly after Pearl Harbor, Ben and his brother Fred were inspired to enlist. Kuroki was eventually admitted to the Army Air Corps, where he served as a machine gunner on a B-24 Liberator bomber. After 30 successful missions, Kuroki was ordered home to boost the flagging enlistment rates at Heart Mountain and other camps. His visit to Heart Mountain inspired multiple stories in the camp newspaper and drew a large crowd. (National Archives and Records Administration.)

Visiting soldiers are entertained in the Heart Mountain USO club, which was the only one in any of the WRA camps. The club was started by Clarence Uno, a World War I veteran from California, who died after attending a USO meeting in January 1943. His son Raymond became the first minority judge in Utah. (National Archives and Records Administration.)

Mildred Miyake Kimball, a former Heart Mountain prisoner, greets her brother, 1st Lt. Howard Miyake, as he arrives in Denver. Both were natives of Hawaii, but Mildred was living in Los Angeles with her husband, a Caucasian sailor in the Navy, when the incarceration started. She was sent to Heart Mountain but eventually relocated to Denver. Howard Miyake was wounded by mortar fire in Italy on June 3, 1944, and was sent back to the United States to recuperate. (National Archives and Records Administration.)

Kei Tanahashi grew up in Los Angeles, where his family ran Asahi Dye Works, a dry-cleaning business in Little Tokyo. He was a member of the Reserve Officer Training Corps at UCLA and left Heart Mountain for graduate school at the University of Nebraska. Tanahashi's exploits received much attention in the *Sentinel*. He was the first Heart Mountain prisoner to die in combat in Italy. (National Archives and Records Administration.)

This memorial was put in place in 1985 to honor the soldiers with Heart Mountain connections who died during World War II. One was Joe Hayashi, one of two Heart Mountain soldiers to receive the Medal of Honor. (Heart Mountain Wyoming Foundation.)

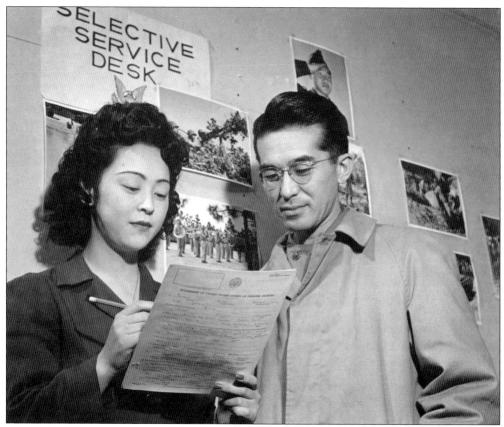

Albert Tanouye was a pharmacist before the war in Los Angeles and later in Heart Mountain. He was drafted in 1944 even though he was 32 years old. Here, he talks with selective service clerk Helen Morioka as he prepares to leave for the Army. (National Archives and Records Administration.)

James Higuchi was a medical doctor in the Army when Pearl Harbor was attacked. He was transferred from Camp Roberts, California, to Camp Chafee, Arkansas. His parents and Amy Iwagaki's parents set up an arranged marriage between James and Amy to keep Amy from being incarcerated. She traveled by train from San Jose to Arkansas alone for their marriage. Here, they sit outside her parents' home in San Jose after his return from Europe. (National Archives and Records Administration.)

The debacle of the 1943 loyalty questionnaire led to congressional hearings calling for the punishment of Japanese American prisoners who were not "loyal" to the United States. The allegedly disloyal prisoners were shipped to the camp in Tule Lake, while the prisoners deemed loyal were sent to Heart Mountain and other camps. Here, a train filled with Tule Lake prisoners heads to Heart Mountain. (National Archives and Records Administration.)

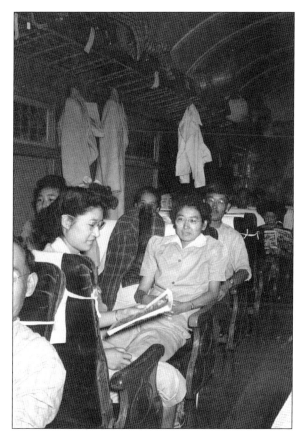

The segregation uprooted hundreds of people in Heart Mountain and sent them to Tule Lake. Here, a group of prisoners gathers outside one of the trains bound for Tule Lake. (National Archives and Records Administration.)

Some of the 600 former prisoners from Tule Lake arrive by train at Heart Mountain. Tule Lake, in the meantime, became the harshest of the 10 WRA camps. (National Archives and Records Administration.)

Trucks carrying baggage from the barracks of Heart Mountain prisoners bound for Tule Lake head toward the train tracks. The 1943 segregation program accomplished little beyond creating more trauma for the people who were uprooted again. (National Archives and Records Administration.)

Some of the Tule Lake prisoners bound for Heart Mountain required special meals. Here, a worker on the train helps with a child who needs a sleeping berth and special food. (National Archives and Records Administration.)

Masakatsu Frank "Match" Kumamoto was a pharmacist in Los Angeles before the war. He was incarcerated at Heart Mountain with his wife and young son, Alan. He left Heart Mountain for a job in Chicago in 1943 and then joined the Military Intelligence Service, where he served in Korea coaxing Japanese soldiers to surrender at the end of the war. (Okumoto collection.)

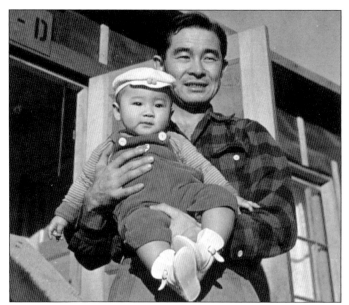

Paul Nakadate, pictured with his son Paul Jr., was an insurance salesman in Los Angeles before the war. At Heart Mountain, he taught social sciences in night school before he became a leader of the Fair Play Committee and was segregated at Tule Lake. (National Archives and Records Administration.)

Sixty-three Heart Mountain resisters were arrested and tried in federal court in Cheyenne, Wyoming, in the largest mass trial in Wyoming history. Shown here in court before the trial started, they were all convicted and sent to federal prisons in Kansas and Washington. Records uncovered by historian Eric Muller revealed that the judge in the case, T. Blake Kennedy, was a virulent racist and anti-Semite. (Frank Abe collection.)

Frank Emi, right, owned a grocery store in Los Angeles before the war. Pictured with a friend from Heart Mountain, he was one of the leaders of the Fair Play Committee with Kiyoshi Okamoto. He returned to Los Angeles after the war and worked for the US Postal Service. Starting in the 1980s, he was an active speaker about the draft resistance. (Frank Abe collection.)

James Omura was the editor of the Denver-based *Rocky Shimpo* newspaper, which was one of the few publications that reported accurately about the Heart Mountain draft resisters. He was tried with the Fair Play Committee leaders and was the only one acquitted. His work, while widely read at Heart Mountain, would eventually make him unemployable after the war. Omura spent the rest of his working life as a landscaper. (Stanford University.)

Takashi Hoshizaki turned 18 while incarcerated at Heart Mountain. He had earlier worked on completing the camp's irrigation channel. He said he always thought the incarceration of Japanese Americans was wrong and said he would only serve in the military if his rights were restored. He was convicted in the first mass trial and sentenced to three years in federal prison. Pictured at an event in April 2024, Takashi later became a PhD botanist who worked for the US space program. (Heart Mountain Wyoming Foundation.)

Ten

BUILDING A FUTURE

The Army ended the exclusion of Japanese Americans from the West Coast on December 17, 1944, with Public Proclamation No. 21. The 8,789 prisoners remaining at Heart Mountain knew they had only days, weeks, or months to remain in camp. Their freedom, however, would prove difficult, because many of them had no homes to which to return.

Prisoners worried about the reactions they would receive if or when they returned to the West Coast. They paid close attention to accounts of violence against returning Japanese Americans and pondered their options, while the government touted how many returned to their former homes and gradually reentered normal life.

In the years after the war, some former prisoners, such as Norman Mineta, rose to heights considered unimaginable in 1942. He became mayor of San Jose, a US House member for 20 years, and a cabinet member for two presidents—Democrat Bill Clinton and Republican George W. Bush. His lifelong friendship with Sen. Alan Simpson of Wyoming, whom he met as a Boy Scout at Heart Mountain, provided the inspiration for Heart Mountain's Mineta-Simpson Institute.

Starting in the 1970s, local Cody and Powell residents noticed that former prisoners were returning to the area to see what was left of their former homes. That led to the creation of the Heart Mountain Wyoming Foundation, which opened its museum and interpretive center on the campsite in 2011.

A large crowd of prisoners walks back to camp after seeing off one of the trains going back to the West Coast after the end of the exclusion order. While most prisoners welcomed the chance to return to their former homes, these partings were often the end of strong feelings that were built in the camp. (Japanese American National Museum.)

A large group of prisoners assembles near a train preparing to leave Heart Mountain. WRA administrators published details of train departure times and destinations to keep prisoners informed about how they would leave. The *Sentinel* published stories highlighting the positive welcomes Japanese Americans received upon returning, but many prisoners feared leaving camp because they did not know where they would live. (Japanese American National Museum.)

Before the war, Sagoro Asai owned a 40-acre fruit ranch in Hood River, Oregon, which he and his family left when they were incarcerated at Tule Lake. They moved to Heart Mountain in 1943 and returned to Hood River in March 1945. Hood River was one of the communities most hostile to returning Japanese Americans. (National Archives and Records Administration.)

Tokuichi and Yone Takagi, shown here, left Heart Mountain for Council Bluffs, Iowa, where they bought a 17.5-acre truck farm in the name of their son George, who was recently drafted. The family eventually returned to California, living in Escondido, where Tokuichi died in 1972. (National Archives and Records Administration.)

Jack Ikemoto, his wife, Susie, and their baby Elaine left Heart Mountain for Des Moines, Iowa, where they lived in a hostel run by Elizabeth Wilbur and her husband. Like many former prisoners, they lived in the hostel until they found a permanent home. (National Archives and Records Administration.)

Haru Ikuta prepares a family meal on her own stove for the first time since evacuation. She, her husband, and their son were the first Japanese Americans from Washington's White River Valley to return home. (National Archives and Records Administration.)

Shigetaka (left), Tamayo (right), and Richard Onishi (center) were among the first former Heart Mountain prisoners to return to California. They arrived at their home at 175 Taylor Street in San Jose in January 1945, shortly after the lifting of the exclusion order. The Onishis had first left Heart Mountain in April 1943 for jobs in Brighton, Colorado. They are pictured with their friend Shigetomo Motoike (behind Richard). Shigetaka Onishi died in 1956, shortly after he became a naturalized citizen. (National Archives and Records Administration.)

The Ouye family of Sacramento gather with their friends the Hayashis on the front porch of their home. They were originally at Tule Lake and transferred to Heart Mountain in September 1943. (National Archives and Records Administration.)

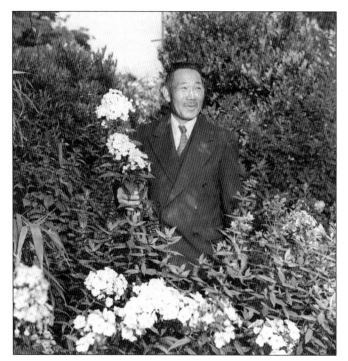

Buemon Kitazawa grew rare shrubs and flowers at his nursery in San Jose. His brother Gijiu Kitazawa returned from Detroit, where he had relocated from Heart Mountain, to help work in the nursery. (National Archives and Records Administration.)

Kura Kai returned from Heart Mountain to run the New King Hotel in Los Angeles. Her husband Saichiro had died in camp on August 7, 1944. She was institutionalized in Brooklyn, New York, camp records show, before returning to Los Angeles. (National Archives and Records Administration.)

From left to right, Judge William F. Hagarty, chairman of the Japanese American Resettlement Committee of the Brooklyn Council for Social Planning, tells Toyo Kichikato and Keinosuke Oizumi about Brooklyn, while Eldon Burke, director of the Brooklyn Hostel for Japanese Americans, listens in. Kichikato came to Brooklyn from Manzanar, while Oizumi arrived from Heart Mountain. Oizumi previously owned a chop suey house in California. He had lived in New York for about three years in the 1920s. (National Archives and Records Administration.)

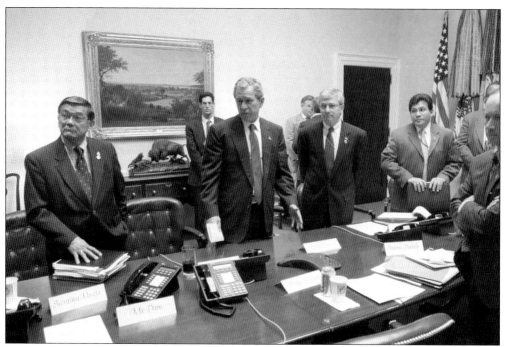

Norman Mineta was incarcerated at Heart Mountain with his family when he was 10 years old. After the war, the family returned to San Jose, where he was elected mayor in 1971 and to Congress in 1974. In 2011, he was secretary of transportation under Pres. George W. Bush. Pictured in the Oval Office, they prevented discrimination against Muslims after the 9/11 attacks. Bush said he would not do to Muslims what the country did to Norm in 1942. (George W. Bush Presidential Library and Museum.)

Mineta was the longest-serving transportation secretary in history. He is receiving the Presidential Medal of Freedom, the nation's highest civilian honor, from President Bush in 2006. (National Archives and Records Administration.)

The Heart Mountain Wyoming Foundation was created in 1996. It eventually raised enough money to build a museum and interpretive center that opened in 2011. Foundation leaders celebrate the opening by cutting a ceremonial piece of barbed wire. (Heart Mountain Wyoming Foundation.)

Heart Mountain Wyoming Foundation leaders break ground on the Mineta-Simpson Institute in July 2023. From left to right are Rep. Liz Cheney (R-Wyoming), Pete Simpson, Shirley Ann Higuchi, Deni Mineta, Alan Simpson, former vice president Dick Cheney, and Aura Sunada Newlin, executive director of the Heart Mountain Wyoming Foundation. (Heart Mountain Wyoming Foundation.)

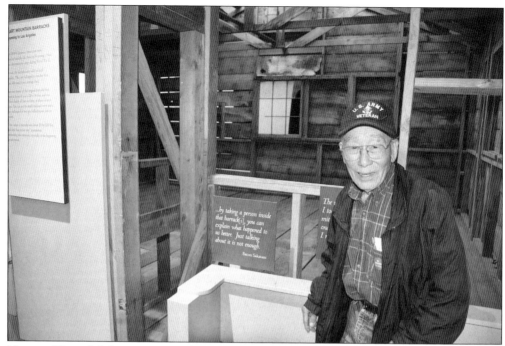

Harumi "Bacon" Sakatani was 13 when he and his family were incarcerated at Heart Mountain. Asked to help with the first reunion of Heart Mountain prisoners in 1982, he researched the history of the incarceration and realized much of what he had been told was wrong. That set off 40 years of activism, including his assistance in obtaining a former Heart Mountain barracks for the Japanese American National Museum, where he is pictured. (Heart Mountain Wyoming Foundation.)

Sam Mihara was nine years old when he and his family were forced from their home in San Francisco into Heart Mountain. He watched his father go blind and his grandfather die of mistreated cancer. Here, he stands in front of a Dorothea Lange photograph of a young girl saying the Pledge of Allegiance at the Raphael Weill Elementary School in San Francisco in 1942. That girl is now Helene Mihara, Sam's wife. (Heart Mountain Wyoming Foundation.)

William Higuchi, Raymond Uno, and Jeanette Mitarai Misaka were members of the same high school class at Heart Mountain. They would all receive the Order of the Rising Sun from the Japanese government for their work in improving relations between the United States and Japan. Pictured from left to right are Shirley Ann Higuchi; William Higuchi; Midori Takeuchi, Japanese consul general in Denver; Misaka; and Uno at Higuchi's 88th birthday party in 2019 in Salt Lake City. (Higuchi family.)

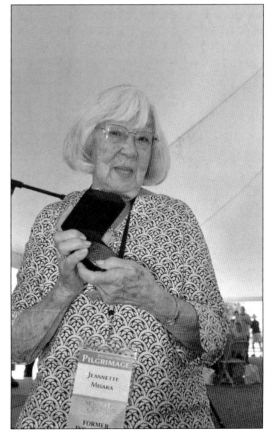

Jeanette Mitarai Misaka, who was photographed with her sisters by Dorothea Lange before their family was forced from their farm in Mountain View, California, is receiving a special award from the Heart Mountain Wyoming Foundation during the group's 2023 pilgrimage to the former prison site. She was instrumental in helping organize the foundation and rallying support for its work. (Heart Mountain Wyoming Foundation.)

A group of 36 teachers from around the country is shown standing in front of Heart Mountain as part of their participation in the Landmarks of American History and Culture program sponsored by the National Endowment for the Humanities. The Heart Mountain Wyoming Foundation is creating educational materials to help spread the word about Japanese American incarceration to students around the country. (Heart Mountain Wyoming Foundation.)

The Jolovich family of homesteaders owned the land where the root cellars built in 1943 by Heart Mountain prisoners stand. They donated this root cellar to the Heart Mountain Wyoming Foundation, which has started a lengthy restoration process. Pictured is the cellar's entrance before the start of restoration work. (Heart Mountain Wyoming Foundation.)

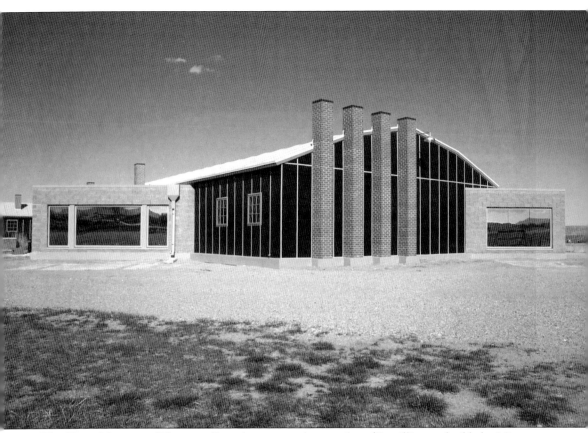

The Heart Mountain Wyoming Foundation raised more than $8 million to build the Mineta-Simpson Institute to honor the lives and careers in public life of Norman Mineta and Alan Simpson, who first met in 1943 as Boy Scouts behind the barbed wire at Heart Mountain. The institute, which opened in July 2024, will feature conferences and educational sessions aimed at spreading the type of public service exemplified by the two men. Mineta, a liberal Democrat from California, and Simpson, a conservative Republican from Wyoming, built careers based on finding common ground with people from different backgrounds and political beliefs. (Heart Mountain Wyoming Foundation.)

Discover Thousands of Local History Books
Featuring Millions of Vintage Images

Arcadia Publishing, the leading local history publisher in the United States, is committed to making history accessible and meaningful through publishing books that celebrate and preserve the heritage of America's people and places.

Find more books like this at
www.arcadiapublishing.com

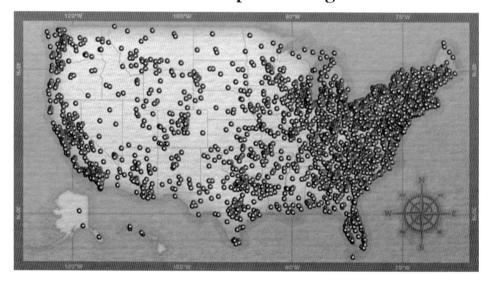

Search for your hometown history, your old stomping grounds, and even your favorite sports team.

Consistent with our mission to preserve history on a local level, this book was printed in South Carolina on American-made paper and manufactured entirely in the United States. Products carrying the accredited Forest Stewardship Council (FSC) label are printed on 100 percent FSC-certified paper.

MADE IN THE
USA